THIS
MEANS
THIS
THIS
MEANS
THAT

A USER'S GUIDE
TO SEMIOTICS

SEAN HALL

LAURENCE KING PUBLISHING

LAURENCE KING

Published in 2007 by Laurence King Publishing Ltd
4th Floor
361–373 City Road
London EC1V 1LR

Tel: +44 20 7841 6900
Fax: +44 20 7841 6910
email: enquiries@laurenceking.co.uk
www.laurenceking.co.uk

A catalogue record for this book is available from the
British Library.

ISBN 13: 978 1 85669 521 3
ISBN 10: 1 85669 521 2

Commissioning Editor: Helen Evans
Cover design and original design concept: Pentagram
Design: Mark Holt
Picture Research: Louise Glasson

Printed in China

Dedicated to
Walter, Shirley and Natasha Hall

CONTENTS

CONTENTS

INTRODUCTION

Starting with the basic concepts of semiotics, *This Means This, This Means That* guides the reader through the morass of meanings that our culture creates. A total of 76 concepts will be explored through a variety of objects, images and texts. Each concept will be presented with a question. Readers are then invited to consider their own response before turning the page to find the author's answer. In this way the reader is challenged to think about how meanings are made, interpreted and understood.

Semiotics is now mentioned regularly in newspaper articles, in magazines and on television. But what exactly is semiotics and why is it important?

Semiotics is defined as the theory of signs. The word 'semiotics' comes from the Greek word *semeiotikos*, which means an interpreter of signs. Signing is vital to human existence because it underlies all forms of communication.

Signs are amazingly diverse. They include gestures, facial expressions, speech disorders, slogans, graffiti, commercials, medical symptoms, marketing, music, body language, drawings, paintings, poetry, design, film, Morse code, clothes, food, rituals and primitive symbols – these are just some of the many things that fall within the subject of semiotics.

To see how signs work, consider the following:

> Stop means Stop
> Apple means Apple
> Crown means Crown

Now compare this:

> Stop means Danger
> Apple means Healthy
> Crown means King

Signs are important because they can mean something other than themselves. Spots on your chest can mean that you are ill. A blip on the radar can mean impending danger for an aircraft. Reading messages like this seems simple enough, but a great deal hangs on context. Spots on the chest need to be judged in a medical context, while a blip on the radar needs to be read within the context of aviation. So signs are not isolated; they are dependent for their meaning on the contexts in which they are read and understood.

The context for some signs seems obvious. For instance, *Toy Story* is an animated film about two central characters, Buzz Lightyear and Woody. Arsenal is an English football club. These are the contexts we use for the purposes of interpreting these things. But are these the right contexts? Perhaps *Toy Story* exists only to sell plastic replicas of the two leading characters to children, and perhaps Arsenal exists only to sell merchandise to its fans. If that is right, then the context for reading these things is not film or football after all, but advertising, and we should alter our interpretation of them accordingly.

Semiotics, then, is about the tools, processes and contexts we have for creating, interpreting and understanding meaning in a variety of different ways.

Sean Hall, London

ACKNOWLEDGMENTS

For full references see the Bibliography on pages 174 and 175

Chapter One. This chapter builds on the ideas first advanced by Shannon and Weaver (1948; reprint 1998), Lasswell (1948) and Gerbner (1956). **Intention** (pp. 21–22) uses Morris (1962). **Noise** (pp. 27–28) employs Sebok (1985).

Chapter Two. This chapter makes use of some helpful markers set down in Chandler (2002).

Chapter Three. The **Introduction** (pp. 53–54) to this chapter employs the seminal work of Levi-Strauss in Levi-Strauss (1969). **Subjectivity and Objectivity** (pp. 61–62) uses some ideas exploited by Nagel (October, 1974). **Sense and Reference** (pp. 67–68) employs a distinction made in Donnellan (1966). **Problem and Solution** (pp. 71–72) makes use of Adams (2001).

Chapter Four. Many of the concepts used in this chapter have received excellent discussion in Arnheim (1974), Arnheim (1988), Kress and Van Leeuwen (2006) and Van Leeuwen (2005).

Chapter Five. Words and Images (pp. 97–98) employs distinctions from Barthes (1977). **Functions** (pp. 99–100) uses Jakobson (1969). **Placing** (pp. 103–4) utilizes an idea expressed in Lidwell, Holden and Butler (2003). **Voices** (pp. 107–8) was inspired by Goddard (2002). **Intertextuality and Intratextuality** (pp. 109–10) and **Paratext and Paralanguage** (pp. 111–12) are motivated by Jackson (1999) and Adair (1992).

Chapter Six. The **Introduction** (pp. 113–14) uses Butler and Keeney (2001). **Concepts and Conceptions** (pp. 115–16) employs an idea by Putnam (1993) and this has its roots in Frege. His central ideas can be found in Beaney (1997). **Connotation and Denotation** (pp. 117–18) draws on Fiske (1990). **Combinations and Substitutions** (pp. 121–22) and **Tokens and Types** (pp. 123–24) make use of a discussion in Chandler (2002). **Rule-following** (pp. 125–26) is inspired by Wittgenstein (1953). **Conventions** (pp. 127–28) uses the seminal work of Gombrich (1986). **Classifications** (pp. 129–30) was aided by Bowker and Star (1999), and by some comments in de Duve (1996). **Understanding and Misunderstanding** (pp. 131–32) uses some information from Varasdi (1996).

Chapter Seven. Genres (pp. 137–38) and **Styles** (pp. 139–40) have been inspired by Van Leeuwen (2005). **Ideologies** (pp. 145–46) draws on Jaworski and Coupland (1999). **Discourses** (pp. 147–48) makes use of Fiske (1990).

Chapter Eight. Fact and Fiction (pp. 155–56) draws on Varasdi (1996). **Legends** (pp. 159–60) makes use of Dale (2005) and Harding (2005). **Characters and Personas** (pp. 161–62) employs Marquart (1998) and Lidwell, Holden and Butler (2003). **Mysteries** (pp. 165–66) makes reference to Barnes (1995). **Turning-points** (pp. 169–70) has an initial idea that I heard John Le Carré discuss in an interview at the National Film Theatre. **Resolutions** (pp. 171–72) employs a story from Reps (1994).

SIGNS AND SIGNING

Signs are everywhere, but how exactly are they formed?

Signs are formed through the society that creates them, by the structures that they employ and via the sources that they use. Let's look at how this works.

Signs are always produced and consumed in the context of a specific society. In the Western world we live in a society that is largely mechanistic and consumerist in outlook. So when it comes to discussing all manner of topics we often use the mechanistic and consumerist metaphors that reflect the dominant views of our society. If we take a fairly concrete topic such as health, we find we will talk in mechanistic terms about, say, the *war* against AIDS or the *fight* against cancer. The same thing applies when we speak about more abstract topics such as 'time'. Here we speak in largely consumerist terms: we talk about *using* time, *wasting* time, *saving* time and *spending* time, as if it were a commodity like money, rather than a process that unfolds. Signs, then, are shaped by different societies in different ways.

The signs that we find in each society are superficially different. However, they often seem to have the same underlying structures. It appears that all human beings, whether ancient and modern, feel the need to tell stories. That is why we find folklore, fairy tales, legends, proverbs, sayings and riddles in all societies, whether they end up in the form of anecdotes, novels, urban myths, soap operas or 'reality' television programmes. But there are other structural similarities too: most societies tend to create hierarchies, perform rituals, play games, adhere to moral systems and engage in forms of symbolic representation.

Societies have two basic sources of signing: the first source is natural, while the second is conventional. For instance, we know that it is natural for humans to wear clothes in cold climates. The kind of clothes we wear, however, and how we wear them, is a matter for convention (i.e., it depends on the 'rules' of the particular society of which we are a part). Consider the wearing of shoes. Shoes can be practical and can afford protection from harsh terrain, but they can also take on meanings that have little or nothing to do with practicality. The wearing of high heels is an instance of this latter phenomenon. In spite of the fact that high heels are highly impractical, they have a very particular

SIGNS AND SIGNING

conventional meaning as sexual symbols in Western societies. (Note, however, that in other societies the wearing of high heels may seem strange and eccentric.)

In due course we will have occasion to explore some of these themes in greater detail. Before that, however, we have to do two things. First, we must show how one thing means another. The concepts that will help us to explain this will include: signifier and signified, sign, icon, index and symbol. These are the basic building blocks for meaning-making. Second, we must describe the sort of journey that a message may take as it travels from sender to receiver. The journey we will describe follows the path set out in the examples below.

The other key concepts we need to examine in this section, then, will include: sender, intention, message, transmission, noise, receiver and destination.

The Journey of a Message	Key Semiotic Concept
A designer	Sender (who)
Wishes to design a vacuum cleaner	Intention (with what aim)
He designs a very efficient vacuum cleaner	Message (says what)
The design is manufactured in plastic and metal	Transmission (by which means)
It is sold in a shop with complex instructions	Noise (with what interference)
A buyer purchases it	Receiver (to whom)
The buyer uses the product by following the instructions	Destination (with what result)
A painter	Sender (who)
Wants to paint a portrait	Intention (with what aim)
He paints a portrait that resembles the sitter	Message (says what)
It is painted on paper with watercolour	Transmission (by which means)
It is hung in a gallery under artificial light, which changes its colour	Noise (with what interference)
A viewer sees it and buys it	Receiver (to whom)
The viewer hangs it over his fireplace where it looks dull	Destination (with what result)
A writer	Sender (who)
Aims to produce a text on semiotics	Intention (with what aim)
He writes a book explaining the complexities of the subject	Message (says what)
It is printed	Transmission (by which means)
A printing error occurs	Noise (with what interference)
A reader reads it	Receiver (to whom)
The reader, not detecting the printing error, is confused	Destination (with what result)

WHAT DOES THE APPLE IN THIS PICTURE SIGNIFY?

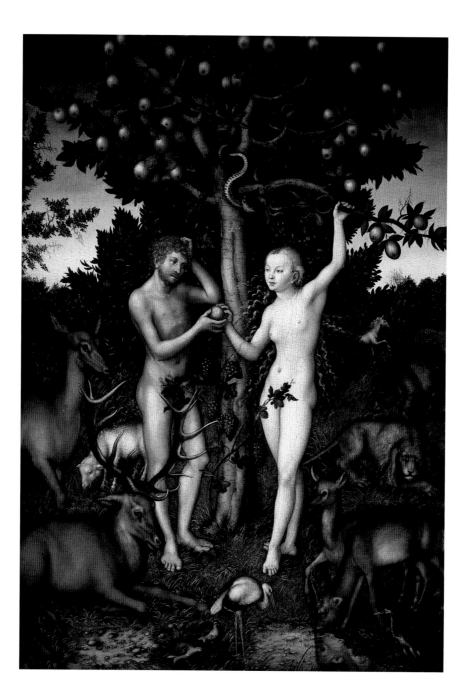

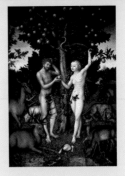

WHAT DOES THE APPLE IN THIS PICTURE SIGNIFY?

This painting by Lucas Cranach (1472–1553) depicts Adam and Eve in the Garden of Eden. The apple represents the fruit of the Tree of Knowledge. Satan, who takes the form of a serpent, uses the apple to tempt Eve. Eve picks the apple and gives it to Adam. With this act Adam and Eve fall from grace in the eyes of God.

It is easy to assume that the image of Eve being tempted by the apple accurately reflects the story in the Bible. But in the Bible there is no mention of an apple. Fruit is mentioned, but not apples. So perhaps it was really an orange that tempted Eve. Or a fig.

What seems to matter in the picture by Cranach is that the apple (what we call the 'signifier') is the fruit used to signify temptation (what we call the 'signified'). However, while the apple means temptation, some other fruit could have been chosen to represent the same idea. It is only because there is already a well-established connection in our minds between the appearance of an apple and the idea of temptation that this fruit is used in the picture. It is this connection that makes the picture successful in terms of communication.

There are numerous relationships that can exist between signifier and signified. Two important things about the relationship stand out though. One is that we can have the same signifier with different signifieds. The other is that we can have different signifiers with the same signifieds.

In the first three examples below, the same signifier gives rise to different signifieds:

Signifier		Signified
Apple	means	Temptation
Apple	means	Healthy
Apple	means	Fruit

However, in the next three examples, different signifiers (depending on whether the language spoken is English, French or German) give rise to the same signified:

Signifier		Signified
Apple	means	Apple
Pomme	means	Apple
Apfel	means	Apple

CAN YOU MAKE SENSE OF THESE DOTS?

CAN YOU MAKE SENSE OF THESE DOTS?

These symbols are written in Braille. In order to decode them you have to know that each set of dots represents a letter, which, in turn, makes up a word. In this case the word is 'blind'. The word 'blind' is the carrier of the meaning. This is the signifier. The meaning of the word, on the other hand, is that which it signifies (e.g., that someone lacks sight).

Signs are often thought to be composed of two inseparable elements: the signifier and the signified. One thing that is intriguing about the relationship between the signifier and the signified is that it can be arbitrary. For example, when I use the word 'dog' in order to talk about a certain furry four-legged domestic creature, I employ a signifier that is arbitrary. The sound made by the word 'dog', when uttered, is intrinsically no better than the made-up sounds 'sog', 'pog' or 'tog' for talking about this animal. All these words could have

been used to communicate the meaning of 'four-legged domestic creature that can make the sound woof'. We just happen to use the word 'dog', while in Germany they have chosen *hund* and in France, *chien*.

Many of the signs we use to communicate are arbitrary in the sense that they are not immediately transparent to us. For this reason they have to be learnt with the conventions of the language in which they are embedded before they can be used. Once these conventions have been learnt, however, the meanings that are conveyed by using them are apt to seem wholly natural. Yet by thinking of meanings as natural we do ourselves a disservice. This is because what is often seen as natural is just the product of various cultural habits and prejudices that have become so engrained that we no longer notice them.

WHAT IS THIS OBJECT?

WHAT IS THIS OBJECT?

This is an Inuit map. It is made from wood. Rather than being visual, it is tactile. The Inuit hold this map under their mittens and feel the contours with their fingers to discern patterns in the coastline. The advantage of this map is that it can be used in the dark, it is weatherproof, it will float if you drop it into the water and it works at any temperature. It will also last longer than one that is printed.

Although the Inuit map is highly abstracted it still resembles the shape of the coastline. While some maps follow the geography of the place that they represent in a fairly exact way, others do not. When specific information about the environment is represented on a map in an abstract way we tend to say that the map is schematic, whereas when a map resembles the world in a more concrete and exact way we say that it is topographical.

With any icon there is some degree of resemblance between signifier and signified. The degree of resemblance can either be high or it can be low (as we have just seen in the case of maps). There are many other examples. For instance, a portrait may look very like the real person or it may look a little like them – enough, say, for them to be recognizable.

Here are some examples of an iconic relationship between signifier and signified:

Signifier		Signified
Line drawing	resembles	The place depicted
Sculpted portrait in clay	resembles	The person portrayed
Coloured photograph	resembles	The object photographed
Sound effect (of footsteps)	resembles	Footsteps
An organic compound	resembles	The smell of roses
A chemical mix	resembles	The taste of cheese and onion

WHAT HAS HAPPENED TO THE WOMAN IN THIS PHOTOGRAPH?

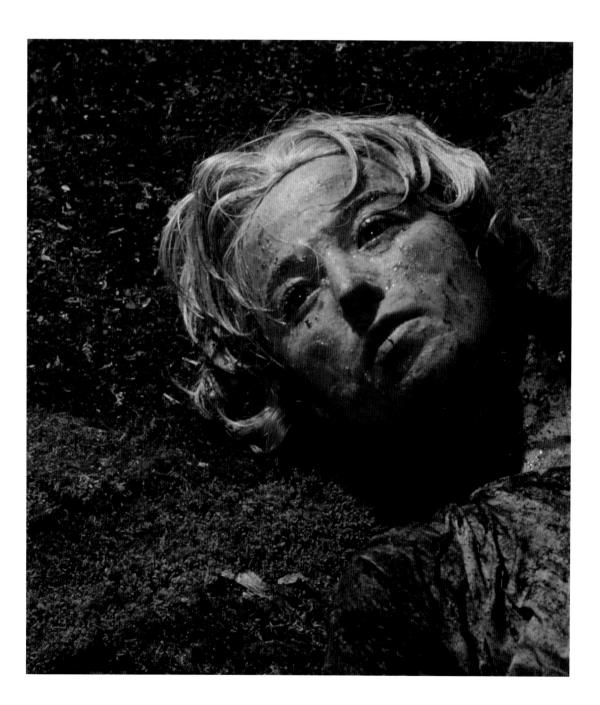

WHAT HAS HAPPENED TO THE WOMAN IN THIS PHOTOGRAPH?

The woman in this photograph by Cindy Sherman looks as if she is dead.

Representational photographs present us with a problem because they often appear to have been caused by real events even when they have been faked. This photograph highlights the very real and disturbing difference between how we might feel about an image of an actual death as opposed to its mere simulation. The photograph also raises the question of how we would be able to tell the difference between the two in certain cases.

When there is a physical or causal relationship between the signifier (i.e., the photograph) and the signified (i.e., what the photograph depicts), the non-arbitrary relationship that exists is said to be indexical.

Other examples of an indexical relationship are shown below.

If only for survival purposes, it is important that we can detect the causal link between a signifier and what is being signified. For instance, we need to know that smoke means (and is often caused by) fire or that a thermometer changing means (and is usually caused by) a rise or fall in temperature. We can see that a failure to detect these things is important when we realize that such a failure can result in mortal danger.

Signifier		Signified
A black eye	is caused by	A punch
A thermometer changing	is caused by	A rise, or fall, in temperature
Smoke	is caused by	Fire
A rash	is caused by	An infection
A knock	is caused by	Someone at the door
A weathercock moving	is caused by	The wind
Ticking	is caused by	A clock
A photograph	is caused by	A real place
A recorded voice	is caused by	A person speaking
A defensive posture	is caused by	An emotional attitude (e.g., fear)
Handwriting	is caused by	A person writing

WHAT DOES THIS SYMBOL MEAN?

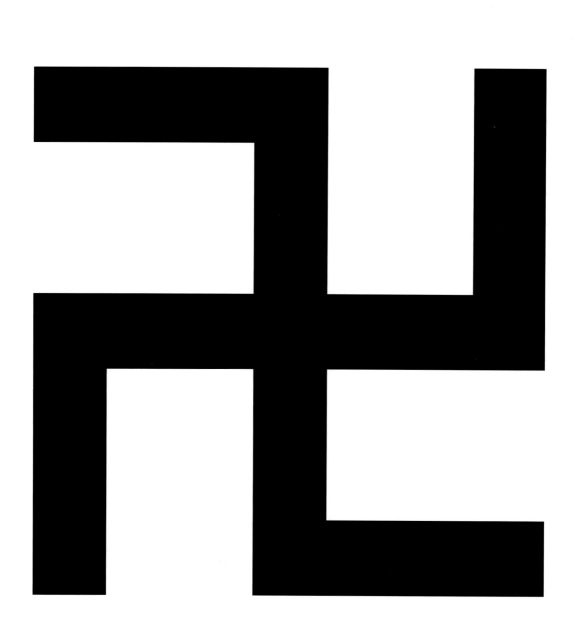

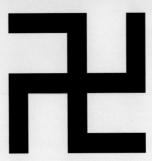

WHAT DOES THIS SYMBOL MEAN?

The symbol on the last page looks like the Nazi swastika. In fact it is an Indian swastika. In Hinduism and Buddhism the swastika stands for good luck. With the Indian swastika the 'L' shape is inverted, unlike its Nazi counterpart.

It is often remarked that the Nazi swastika is a powerful and disturbing symbol. The word 'symbol' in Greek means 'to throw together'. In semiotics one thing can be 'thrown together' with another in such a way that a relationship is created whereby the first symbolizes the second. Here are some obvious visual examples:

Symbol	Meaning
Scales	Justice
Dove	Peace
Rose	Beauty
Lion	Strength

With these symbols the meaning that is created is related to the nature of the object: balance is important for justice; doves are peaceful creatures; roses are beautiful; and lions are strong. However, there are some symbols where the relationship between the symbol and its meaning is less obvious:

Symbol	Meaning
Sword	Truth
Lily	Purity
Goat	Lust
Orb and Sceptre	Monarchy and Rule

With these examples we need to know what the symbols stand for in advance if we are to understand them. We can't work it out just by looking at them. In semiotics the word 'symbol' is used in a special sense to mean literally any sign where there is an arbitrary relationship between signifier and signified. In other words, it is wider than the more traditional sense of the word 'symbol', as used above. The following, then, are also symbols in semiotics:

Signifier		Signified
Shaking hands	Arbitrary relationship	A greeting
Black tie	Arbitrary relationship	A formal occasion
Bleep, bleep	Arbitrary relationship	The telephone needs answering
A black flag	Arbitrary relationship	Danger
Cheese	Arbitrary relationship	The end of a meal
The word 'cat'	Arbitrary relationship	A cat

WHO IS SENDING THIS MESSAGE?

I am black.
I am six years old.
I am an orphan.
I am African.
I am poor.
I am a liar.

> I am black.
> I am six years old.
> I am an orphan.
> I am African.
> I am poor.
> I am a liar.

WHO IS SENDING THIS MESSAGE?

The first five sentences in this speech bubble provide information that helps us to form a picture of the individual who we think is sending the message. The information tells us who the person is, how old they are, where they come from and what their life is like.

However, the last sentence seems anomalous, and may lead us to ask certain questions. Is this a message from a child who lies about certain things? Is the whole message a lie? Is this a genuine message? Or is it just a fictional piece of dialogue?

A six-year-old black child did not write the sentences in this speech bubble. The author of this book wrote them. But has the 'real' sender of the message, namely the author, chosen them for a special reason? Is he just using them to make a point about the difference between the real author (himself) and an authorial persona (the person he might pretend to be)? Or is there some other meaning that lies behind these words?

Consider the following speech bubble:

> I am an author.
> I am 45 years old.
> I am not an orphan.
> I am English.
> I am not poor.
> I am not a liar.

These sentences provide us with vital information about another putative person. But, once again, we can ask: 'Is this person real or is he fictional?'.

It is always important to remember that where a message *says* it is from may be very different from where it is *really* from. The former is what we call the 'addresser'. This consists of a message that is constructed, and it may be real or imaginary. On the other hand, the latter is what we call the 'sender'. This consists of a message from a real person. Of course, whether we can always tell the difference between these two things may be another question.

WHAT DO YOU THINK OF THIS PICTURE?

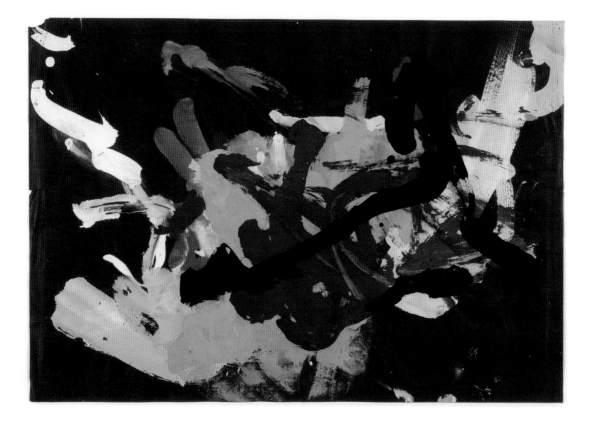

WHAT DO YOU THINK OF THIS PICTURE?

Even if we *ought* to judge a picture, object or piece of text in isolation from the intentions of its maker, this is hard to achieve in practice. Consider the painting on the previous page. There are several possibilities as to its creator. An adult, a child or a machine might have made it. Surely if we can discover who made it, that will influence the way that we judge it, whether or not it ought really to influence us.

In fact, a chimpanzee called Congo made this picture. Once you know that it is hard to see it in the same way. Over the course of his life Congo completed around 400 drawings and paintings. He was the subject of a study into the drawing and painting abilities of apes by the behavioural psychologist Desmond Morris. Morris argued that the fundamentals of creativity could actually be discerned in the paintings of apes. He claimed that a sense of composition, calligraphic development and aesthetic sensibilities are apparent (even if only at a minimal level) in the picture-making of apes.

Now imagine that I lied. Suppose a well-known artist created this picture. You might also suppose that the work of this (human) artist sells for vast sums of money. Once we know that a human being rather than an ape produced this image do we start to see it differently? Do we read human intentions and feelings into the picture where there were none before? Do we also begin to see aesthetic qualities in the image that were not present before? And do we also see monetary value in the picture that was not there before?

Whatever you think of this work, and however you would wish to judge the person or thing that made it, it is hard not to be influenced in our judgements by what we take to be the intention behind it.

WHAT IS THIS MESSAGE REALLY SAYING?

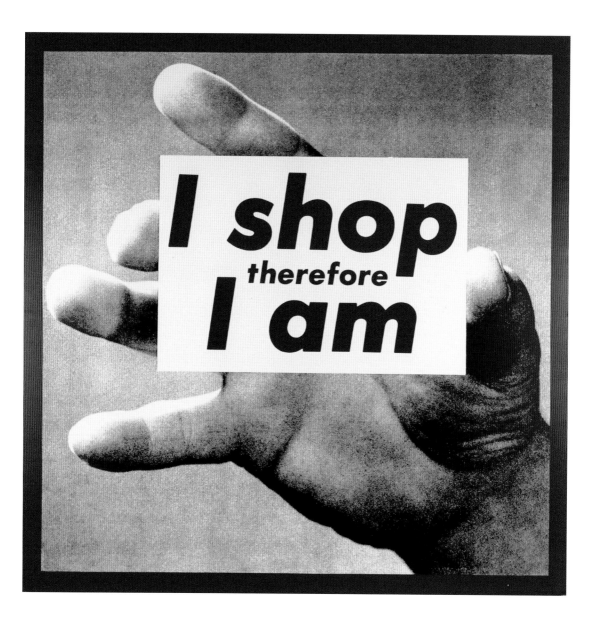

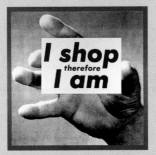

WHAT IS THIS MESSAGE REALLY SAYING?

The meaning of the message seems obvious. It appears to be saying that shopping gives us a sense of who and what we are as human beings.

Perhaps there is a deeper message though. To see this we need to understand that 'I shop, therefore I am' is derived from 'I think, therefore I am', which was used by the seventeenth-century French philosopher René Descartes.

Descartes was the first modern philosopher. He believed that to build a system of knowledge one must start from first principles. To find secure foundations for his philosophy he employed what he called 'the method of doubt', which consisted in trying to doubt everything that it was possible to doubt. This led Descartes to the conclusion that there was only one thing of which he could be certain, the famous *cogito ergo sum* ('I think, therefore I am'). The idea behind the *cogito* was this:

If I think, it follows that I think.
If I doubt that I think, it also follows that I think.
Therefore, either way, it follows that I think.

'I think, therefore, I am' and 'I doubt, therefore, I am' were equally true for Descartes, as even doubting is a kind of thinking. This enabled Descartes to conclude that what I am, fundamentally, is a 'thinking thing'.

The deeper message behind 'I shop, therefore I am', then, may be this: it is surely ironic that where once we would try to secure our belief systems on foundations gained by the profound activity of philosophizing, we now rely on the trivial and banal-seeming activity of shopping to tell us who and what we are.

We can scarcely imagine a world without the messages of advertising. But take a moment to think about how we would view the world if all advertising suddenly disappeared.

HOW IS THE MESSAGE OF THE *MONA LISA* TRANSMITTED?

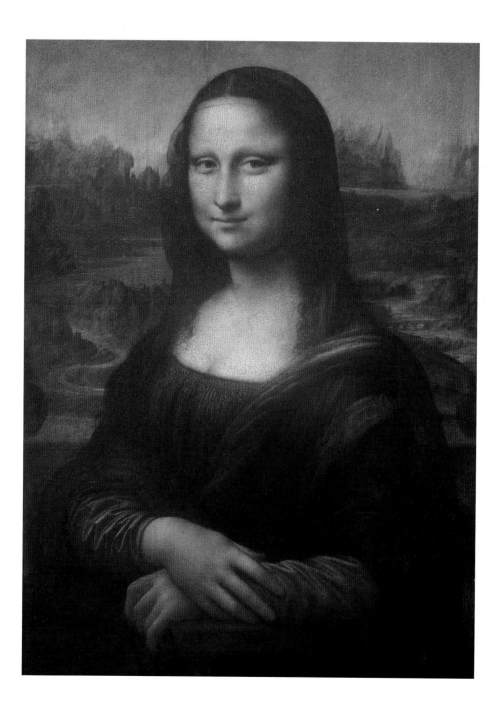

HOW IS THE MESSAGE OF THE *MONA LISA* TRANSMITTED?

Messages are always transmitted though a medium. The medium carries the message from the sender to the receiver. The medium may be:

Presentational: through the voice, the face (or parts of the face such as the mouth or the eyes) or the body (or parts of the body such as the hands).

Representational: through paintings, books, photographs, drawings, writings and buildings.

Mechanical: through telephones, the internet, television, radio and the cinema.

The message of the *Mona Lisa* is transmitted through all three mediums. It uses the presentational medium of facial expression, the representational medium of painting (in its original form) and the mechanical medium of the internet and television (in its digital form).

The enigmatic expression of the *Mona Lisa* is often remarked upon. To see how this expression is transmitted, consider the following drawings:

In both of these drawings the eyes are identical in terms of shape, tone and position. What makes the eyes in the first picture seem happy, and the eyes in the second picture seem sad, is the mouth. The mouth is the transmitter of emotion; the eyes themselves are expressionless.

So even though we know that the charm of the *Mona Lisa* lies in her gentle smile, the lesson from these highly abstracted images of a face may be that very little is transmitted to us by the eyes. The eyes, it seems, are not the windows of the soul after all. The window of the soul is the mouth.

HOW SHOULD WE COMMUNICATE DANGER TO FUTURE GENERATIONS?

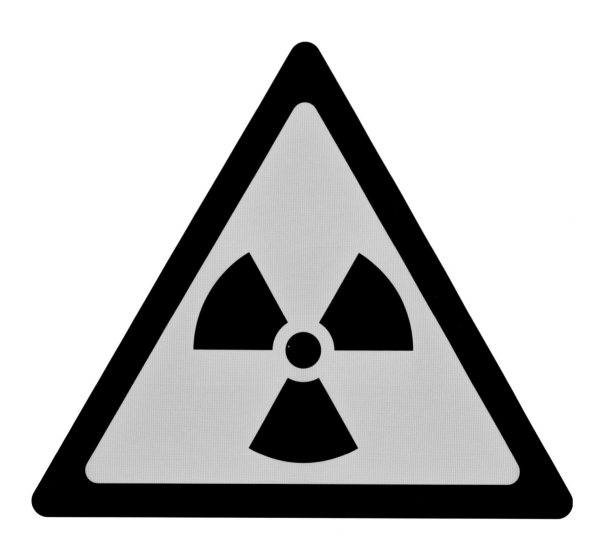

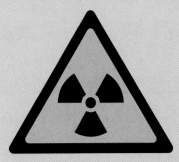

HOW SHOULD WE COMMUNICATE DANGER TO FUTURE GENERATIONS?

Imagine that you had to tell someone living in 2000 years time about a danger that exists now. Commercial nuclear reprocessing has ensured that thousands of gallons of dangerous radioactive liquid will still be active in thousands, perhaps hundreds of thousands, of years to come. And if we don't tell future generations where and how we have stored this waste they may be exposed to it without suspecting that it is highly toxic.

Communicating danger to people in the future seems to be simple. But it isn't. This is because over such a long period a message can easily be distorted or altered without this being in any way intended. (This distortion or alteration in the meaning or method of transmission of a message, whether intended or not, is called 'noise'.) Languages, both written and spoken, always change. The meanings of symbols are often lost in the passage of time. In fact, most messages are bound so closely to a particular period and place that even a short time later they cannot be understood. Therefore, ensuring that a message created now can be decoded by future generations is highly problematic.

How to pass on messages about this nuclear peril is not obvious. Perhaps we can use words, pictures, mathematical symbols, smells and sounds to help us. Perhaps we can create a culture that will spread the myths necessary to deter any curiosity about the nature of these storage systems if they are chanced upon. The prospects, however, seem bleak. Even when you think that you have a message that is clear and precise in the present, it can still be misinterpreted. And that, as we know, can lead to disaster.

HOW WELL DO YOU UNDERSTAND HIM?

Suppose a grandfather
says to his granddaughter:

I didn't eat Grandmother's chocolate cake.

Suppose a grandfather
says to his granddaughter:

> *I didn't eat
> Grandmother's
> chocolate cake.*

HOW WELL DO YOU UNDERSTAND HIM?

Did you interpret it as one of the following?

I didn't eat Grandmother's chocolate cake.
(Paul ate Grandmother's chocolate cake.)

I didn't *eat* Grandmother's chocolate cake.
(I sat on Grandmother's chocolate cake.)

I didn't eat *Grandmother's* chocolate cake.
(I ate Susan's chocolate cake.)

I didn't eat Grandmother's *chocolate* cake.
(I ate Grandmother's fruitcake.)

I didn't eat Grandmother's chocolate *cake.*
(I ate Grandmother's chocolate biscuit.)

How we make sense of this message depends on
how we interpret it and who we think is receiving it.
The message says that it is being sent to a certain
granddaughter. However, the granddaughter is
actually imaginary. The person who is receiving the
message is really a reader of a book on semiotics
(namely you!). That is why in semiotics there is a
distinction between the 'receiver' (the actual person
who gets the message) and the 'addressee' (the
person, whether real or imaginary, who is said to be
the target of the message).

Below are some examples of familiar fields of
communication with different senders and receivers.

In all these cases a message travels between a sender
and a receiver *in* a specific context and *through* a
specific object. The aim of the sender is to make sure
the message has reached the right receiver without
anything going wrong.

Sender	Communication	Receiver	Context	Object
Writer	Message	Reader	Literature	A book
Performer	Message	Audience	Drama	A play
Producer	Message	Consumer	Retail	Some clothing
Maker	Message	User	Design	A piece of furniture
Painter	Message	Viewer	Art	A drawing
Singer	Message	Listener	Music	A song
Transmitter	Message	Recipient	Technology	A telephone

HOW DO YOU FEEL ABOUT THIS PICTURE?

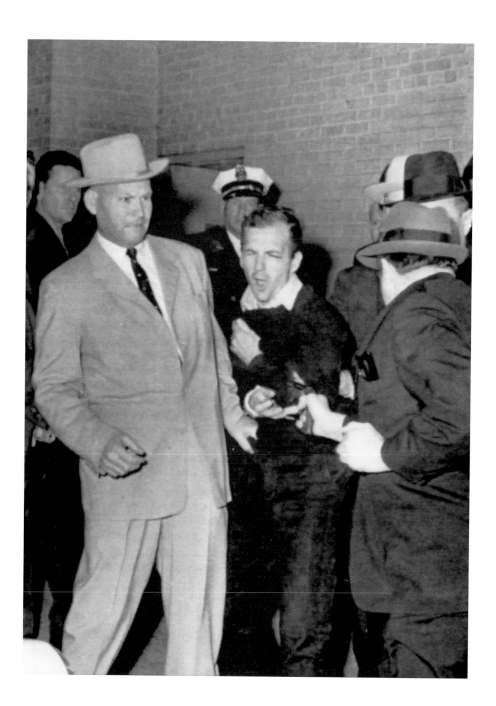

HOW DO YOU FEEL ABOUT THIS PICTURE?

This photograph was taken on Sunday, November 24th, 1963. It shows the murder of Lee Harvey Oswald by Jack Ruby. Lee Harvey Oswald is said to have murdered President John F. Kennedy on the afternoon of November 22nd, 1963. However, many conspiracy theories remain surrounding the assassination.

The murder of Lee Harvey Oswald and the assassination of President Kennedy are well-known historical events. But how we feel about these events changes according to what historians (and conspiracy theorists) tell us. For example, you may think that the murder of Oswald is deplorable until you discover that he killed Kennedy. You may think that Oswald was not the person who really killed Kennedy and hence that his murder by Ruby was unjustified. Or else, the shooting may seem shocking when you discover that Ruby *may* have been a mobster, an intelligence agent and small-time hustler who allowed himself to shoot Oswald simply out of a sense of moral indignation.

When the message in this photograph has been successfully decoded and interpreted we can say that it has reached its destination. The destination is the end point in the journey of the message. One problem in semiotics is that the message that arrives at the destination is not always the same as the one that has been sent. The problem occurs because the message can be altered during its journey. This can happen due to the quality of the message, because of an ambiguity in its expression, or it can come down to failure in its transmission, whether intended or not. In this instance, our ability to decode and interpret the message depends very much on what we know about, and how we judge, the historical events that surrounded the murder of Lee Harvey Oswald.

WAYS OF MEANING

Sometimes we mean what we say. Suppose I look intensely at a painting. Then I remark, 'The colours are very bright'. What I have said may be literally true. Perhaps I have made this comment because the colours really are very bright. But what I say may not always be what I actually mean. This is because when I say, 'The colours are very bright', I might say it in a sarcastic way. Sarcasm changes the meaning of what I have said. The sarcasm in my voice indicates that what I really mean is that the colours are dull. And in saying that the colours are dull I may be implying that I don't approve of, or don't like, paintings like this. If I am being sarcastic, then I am literally saying one thing while meaning another.

There are various ways not to mean what you literally say. Strange similes and bizarre metaphors, clever metonyms and genuine ironies, little lies and genuine impossibilities, unusual depictions and curious representations are all of interest to those who study semiotics because they allow us to say what we mean in a non-literal way. These non-literal forms of meaning enable us to make the familiar seem unfamiliar and the unfamiliar seem familiar.

Occasionally we have to work hard to understand what someone is really saying. This may be because what is being communicated is obscure, but it could also be because what they are saying is not literal. When we mean something other than what we communicate literally we may have to explain ourselves. This is because literal communication is more dominant, and more common, than non-literal communication. However, even though literal communication is very useful (e.g., medicine would be very difficult without it), often non-literal communication is more interesting and no less important. That is why advertising agencies, poets, humourists, film-makers and painters often use it. After all, the truth about the world is often more beguiling if we have to do some work in order to

WAYS OF MEANING

understand it. And non-literal communication will always make us work harder when it comes to deciphering the various meanings that human beings create.

There are numerous devices that we can employ to produce meanings of a non-literal kind. The key concepts, as we have already suggested, include:

simile, metaphor, metonym, synecdoche, irony, lies, impossibility, depiction and representation. All of these concepts can help us to produce new insights into the meanings of objects, images and texts. And all of these things, if used judiciously, can be used to create more resonant meanings in such disciplines as painting, design, advertising, illustration, film-making, fashion and journalism.

WHICH THREE ITEMS ARE MOST ALIKE?

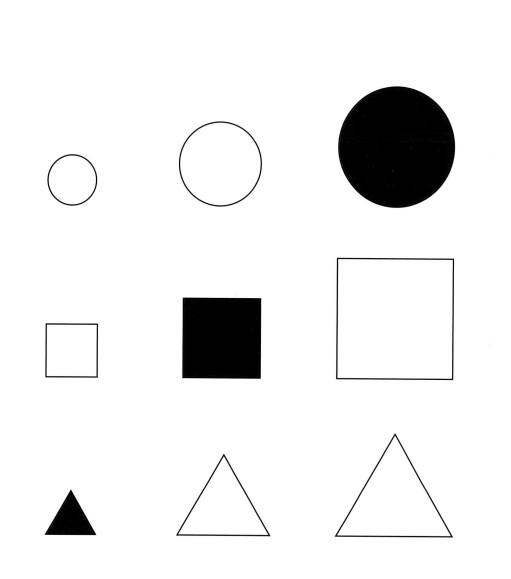

WHICH THREE ITEMS ARE MOST ALIKE?

The answer depends on what interests you. We could pick three that are alike in form, three that are alike in size or three that are alike in colour.

When we liken one thing to another we tend to highlight the features that interest us, and we ignore those that don't interest us. The likening of one thing to another is called a simile. A simile is a stated comparison between two different objects, images, ideas or likenesses. In everyday life we often use similes without even noticing. They often occur in figures of speech (e.g., busy as a bee, dead as a doornail, flat as a pancake and crack of dawn). Similes are not confined to verbal communication though. They also occur regularly in visual communication. For example, using an image of a light bulb above the head of a person to represent the idea that they have just had a thought, or employing an image of a heart to represent love, are well-known visual similes. (They are also clichés.)

Artists and designers are always trying to find new similes. For instance, while a hedgehog is not a brush, it is like a brush in respect of its bristles. Here is how we might think:

First Object	Linking Property	Second Object
Hedgehog	Bristles	Brush

This simile is suggestive because if a hedgehog is like a brush then that might suggest that we could design a brush that looks like a hedgehog. The helpful simile, then, is the one that enables us to see an old object or image in a new light by making a connection with another object or image in respect of a certain property or feature.

HOW IS THIS EQUATION POSSIBLE?

 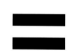 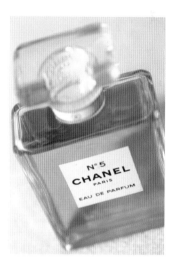

 =

HOW IS THIS EQUATION POSSIBLE?

With a metaphor there is an implied comparison between two similar or dissimilar things that share a certain quality. With a simile we say that x is *like* y, while with a metaphor we say that x *is* y.

Objects, images and texts can all be used to create metaphors. Metaphors are often at their most interesting when they link something familiar with something unfamiliar. By drawing attention to the ways in which a familiar thing, x, can be seen in terms of an unfamiliar thing, y, we help to show that the qualities of the first thing are more like the second thing than we had initially thought. Metaphors, then, work by a process of transference. This process of transference shows that while x doesn't have certain properties literally, it can still have them metaphorically.

When they work, metaphors can also be very persuasive. The schema below shows how the metaphor on the previous page works to persuade us of the qualities of the product.

Signifier	Linking Notion	Signified
Person (e.g., Carole Bouquet)	= Abstract Concepts (e.g., beauty and elegance)	= Object (e.g., perfume)

The aim of Chanel is to find a metaphorical equivalent for that which they wish to signify (namely, a bottle of perfume). The model Carole Bouquet is a suitable candidate because she has the kind of qualities that the perfume is supposed to embody (i.e., beauty and elegance). Notice, however, that the advert could have used a different signifier. Had the designer of the advert thought of highlighting a different set of properties then it might have been structured in the following way, by using a thing rather than a person:

Signifier	Linking Notion	Signified
Thing in nature (e.g., a waterfall)	= Abstract concepts (e.g., naturalness and freshness)	= Object (e.g., perfume)

HERE IS ONE ANSWER:

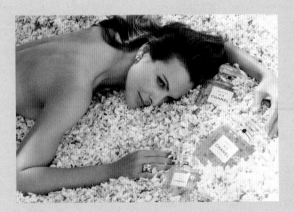

WHICH NATIONALITY IS REPRESENTED BY THIS OBJECT?

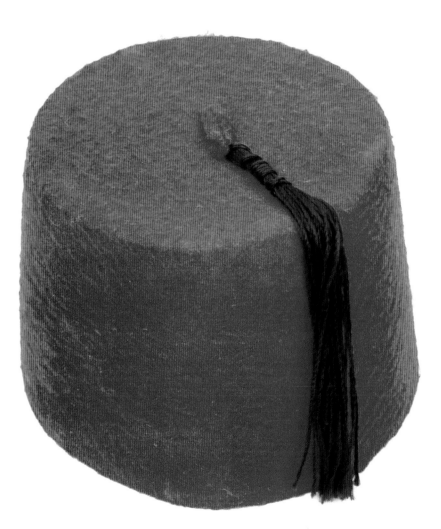

WHICH NATIONALITY IS REPRESENTED BY THIS OBJECT?

When one thing is closely associated with – or directly related to – another, it can be substituted for it so as to create meaning. A crown might be used to mean a queen, a shadow in a film might indicate the presence of a murderer and a sign with an image of an explosion might represent the presence of a dangerous chemical. What is curious about these examples is that the thing actually depicted (a crown, a shadow or an explosion) is used to stand for something that is not depicted (a queen, a murderer, a chemical). Thus, while the thing that is being referred to is missing, its presence is still implied.

When one thing is substituted for another in a piece of communication we call it a metonym. Metonyms use indexical relationships to create meanings. Below are some examples of metonyms.

The intriguing thing about all of these metonyms is that they depend on extensive cultural knowledge. So in order to know which nationality is being represented by the fez on the last page you have to know that they are worn in Turkey. (Though note that a fez may also stand for a particular type of user – a Turkish man of a certain age.)

Things		Meaning
Statue of Liberty (object)	indicates	Freedom (concept)
A brush (object)	indicates	Painting (activity)
A throne (object)	indicates	A monarch (person)

Images		Meaning
A cartoon of a flattened thumb (effect)	indicates	The presence of a hammer (cause)
A picture of the White House (place)	indicates	The president of the USA (person)
A photograph of a jacket (object)	indicates	A shop where clothes are sold (place)

Words		Meaning
Watergate (place)	indicates	The impeaching of President Nixon (event)
Charleston (place)	indicates	Dancing (activity)
Einstein (person)	indicates	Genius (concept)

CAN YOU RECOGNIZE THIS PERSON BY THEIR HAIRCUT?

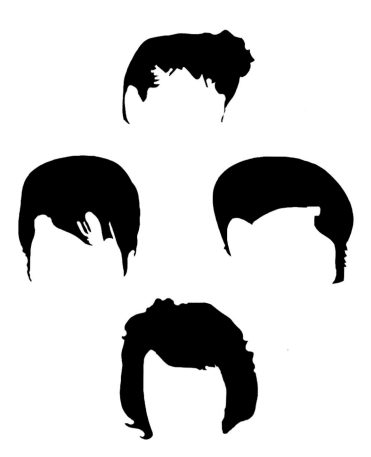

CAN YOU RECOGNIZE THIS PERSON BY THEIR HAIRCUT?

The person is Elvis Presley.

Sometimes in semiotics what matters is not what you put into a piece of communication, but what you leave out. In order to represent Elvis you may only need to use part of him. In this case his haircut will suffice. Using a part of something to stand for the whole thing, or the whole thing to stand for part, is called synecdoche. Another example might be this: using an Italian to represent the people of Italy (here the part stands for the whole) or using a map of Italy to represent an Italian person (here the whole stands for a part).

The part/whole relationship is one example of synecdoche. Other examples include that between member and class, species and genus and an individual and a group. Here is an example of the last kind. Newspapers and television programmes often use individual people to stand for a category of persons that they want to portray as a group. So they will report on a story about a particular criminal who is intended to stand for criminals as a group. This works as an act of persuasion because it is easy to get human beings to move from thoughts about a specific case to thoughts of a more general kind that are also negative. In this instance, the activities of a specific criminal will serve to remind us of why we dislike criminals as a group.

Suppose you were given the task of raising money for a charity for the poor. Would it be better to provide abstract statistics concerning the malnourishment of your target group or would you be better off presenting a story about a particular person in that group who was malnourished (and in that way use them to represent the group that you are trying to help)? Those advertisers who are fond of using synecdoche in their work would probably opt for the latter, because the personal case will tend to awaken more sympathy than a set of rather impersonal statistics.

WHAT IS IRONIC ABOUT THIS VASE?

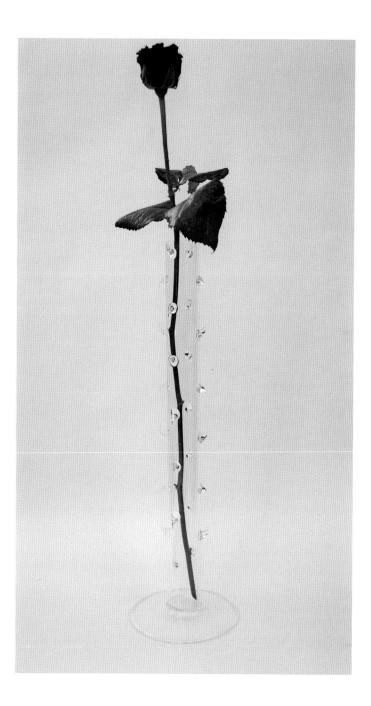

WHAT IS IRONIC ABOUT THIS VASE?

This work is called *A Vase By Any Other Name*. It was designed by Sean Hall.

A vase for a rose is supposed to sustain the flower, while also protecting people from its thorns. The irony of this work is that it does afford protection from the stem of the rose, but at the same time creates what looks like an equal problem by situating a number of glass thorns on its outside surface. Irony is used in this context to highlight features that will serve to create an effect that is at once amusing and lightweight.

Irony is about opposites. When someone makes an ironic statement they will use the word 'love' when they mean 'hate', or the word 'true' when they mean 'false', or 'happy' when they mean 'sad'. In speaking like this they are expressing a belief or feeling that is at odds with what they are saying on the surface. Irony of this kind can occur in everyday speech, but it can also occur in works of literature, music, design and art.

The problem with using irony is that people don't always notice it. This is because if something looks serious on the surface then it is all too easy to take it seriously. In order to communicate the fact that you are being ironic, then, you may need to engage in gross understatement or gross overstatement. However, by exaggerating things in this way to make yourself clearer to others your ironic comment may lose some of its power. So to be ironic in the first place might require a culture in which irony is regularly used and understood.

IS THIS SENTENCE LYING?

This sentence is false.

This sentence is false.

IS THIS SENTENCE LYING?

It is sometimes hard to tell where the truth ends and lies begin. That may be true of this sentence. Or it may not be.

So what is a lie? A lie is a claim that is literally false. It is, therefore, unlike a factual description, which is true. It is also unlike a prescription, which, given its status as an opinion, is neither true nor false. It is like an ironic comment, at least in terms of its modality (see below), as it is literally false. However, it is quite unlike an ironic comment in that it is not intended to amuse, so much as to mislead.

To see the difference between facts, values, irony and lies consider someone who says, 'That's a good haircut'.

Lies are built into the fabric of everyday life. Lies are like truths in being almost never pure and rarely simple. The catalogue of human lies – which depend for their existence on liars of various kinds – has been compiled over centuries by (amongst others) storytellers, biographers, painters, advertisers, politicians, salesmen, lawyers, children, and the list could continue. In fact, a liar is anyone who has an interest in cheating, deceit, selfishness, exaggeration, pretence and distortion.

But does that make lying bad? Not necessarily. For perhaps semiotics is about creating the lies that make us see the truth.

Status	Surface Message	Underlying Message	Modality	Intention
Fact	'That's a good haircut'	That haircut has been done skilfully	True	To inform
Value	'That's a good haircut'	I like that haircut	Not true/Not false	To judge
Irony	'That's a good haircut'	That haircut is awful	False	To amuse
Lie	'That's a good haircut'	That isn't a good haircut*	False	To mislead

N.B. This could be a lie about factual information (because the haircut has not been done skillfully) or a lie about my preferences (because I do not like the haircut).

IF YOU ADD A SQUARE TO A CIRCLE DO YOU GET A SQUARE CIRCLE?

IF YOU ADD A SQUARE TO A CIRCLE DO YOU GET A SQUARE CIRCLE?

If something is not literally possible we say that it is impossible. But things can be impossible in different ways. A square circle is not logically possible – though that may not stop us trying to imagine one. The fact that there are no people from the future here now might suggest to us that backwards time travel is not scientifically possible – yet film-makers often try to represent it. It is physically impossible for human beings to fly unaided (unless, perhaps, they attempt it in zero gravity), but that does not prevent speculation – and dreaming – about what it might be like to have the experience.

What is literally possible sets a limit for us. Possibilities (and impossibilities) that go beyond what is literal are rather less limited. In fact, it might be said that

contemplating impossibilities is actually liberating, both intellectually and imaginatively. It may be impossible to ignore a notice that says, 'Please Ignore This Notice'. It may be impossible to know everything. It may be impossible to understand infinity. It may be impossible to step into the same river twice. It may be impossible to think of nothing. It may be impossible to slow life down – or even stop it. It may be impossible to experience death itself (rather than the process of dying). Yet all of these 'impossibilities' open up our thinking in different ways.

That which is not possible has meaning for humans in a way that it cannot for other animals. Other animals are limited because they are actually too literal.

WHAT IS DEPICTED ABOVE THE HEAD OF THE CENTRAL FIGURE?

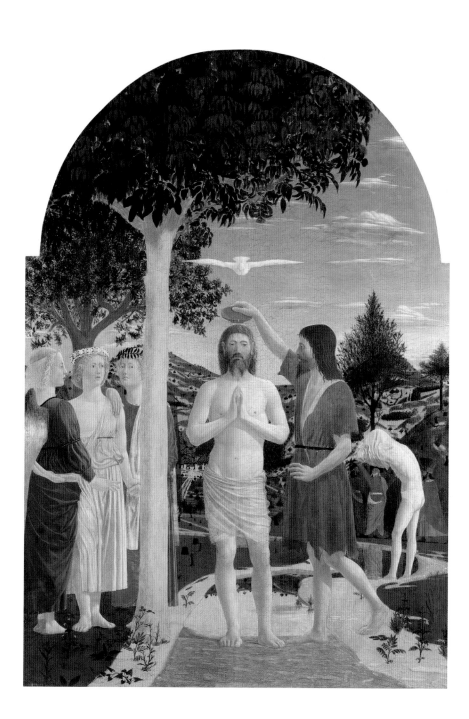

WHAT IS DEPICTED ABOVE THE HEAD OF THE CENTRAL FIGURE?

The answer seems easy. It is a bird. And the bird looks like a dove. However, knowing what is being depicted in a picture is not as simple as it looks. This is because in order to know *what* is being depicted we may need to know *how* it is being depicted.

In this case, the dove is depicted in perspective. Perspective is a convention that has to be read correctly if it is to be understood. It is not something that is simply transparent to the viewer of an image – even if it sometimes seems so. Nor is it a mere recording of what appears on our retinal image. Instead, perspective is a code that has to be properly interpreted if it is to be deciphered. And for the code to be deciphered the viewer needs to realize how objects can present different facets of themselves from different angles,

and how shadows and shading change when an object is viewed from these different positions. (For example, looking straight at an object is very different from looking up at it or down at it.)

What is depicted in a picture may also be different from what it represents. In this picture by Piero della Francesca we see a dove. The dove is the object depicted. But the dove represents the Holy Ghost. So when we want to know what is depicted in a picture we need to ask: 'What is the picture of?' And when we want to know what is being represented we need to ask: 'What does the thing depicted in the picture mean?' While a picture of a dove may mean that there is a dove, it may also mean something else entirely.

WHAT DOES THIS DRAWING REPRESENT?

WHAT DOES THIS DRAWING REPRESENT?

It looks a bit like a drawing of a hat. Does the drawing only represent a hat, though, or does the hat in turn represent something else? And how can we tell?

Actually, this is a picture of a boa constrictor digesting an elephant. The elephant is inside the boa constrictor so you can't see him. The image is taken from Antoine de Saint-Exupéry's children's book *The Little Prince*. The narrator of the book explains the picture with seeming exasperation, because, as he points out, grown-ups always have to have everything explained, whereas children, who often have better insight into such things, do not. (This point, of course, is intended to appeal to the children, who are supposed to be the main readers of the book.)

And that sentiment is right when it comes to representation. Adults often have to have things explained to them. As adults we find that interpreting a drawing made by a small child can be quite difficult, because while the meaning of the drawing is often transparent to the child it is frequently opaque to the adult. The problem is often that the adult needs more information to be provided in order to understand what the child is trying to say. Indeed, when we ask a young child what they have drawn in a picture we often find that something that we did not expect has been presented to us.

What is fascinating about children is that while they are often literal in their approach to perception, they are naive as regards the conventions of representation. This means that they may devise highly creative forms of representation that as adults we would never consider. It may have been this point that Picasso had in mind when he pointed out that it took him his whole life to gain the insight needed to draw like a child.

CONCEPTUAL STRUCTURES

We often use the word 'concept' when we want a more exact equivalent for the word 'idea'. Here are some examples of concepts: human being, cat, house, table, chair, computer, tree, painting, book, square, soft, red, unicorn, object, image, text, atom, universe, beauty, truth, sameness and whole. As we can see from this list, concepts come in all shapes and sizes. They can be general or specific, concrete or abstract, natural or technological, artistic or scientific.

Concepts are the basic building blocks in human thinking, and as such they are highly flexible. They can apply to things that are real (e.g., people and cats) or imaginary (e.g., unicorns and fairies). They can help us to make distinctions between things that we observe in the world, for instance, tables and chairs, oak trees and elm trees, atoms and molecules. They can also aid us in distinguishing different ideas in our minds, such as truth and falsity, appearance and reality and continuity and discontinuity.

Pairs of opposing concepts provide a particularly useful structure for study in semiotics as they assist us in interpreting and exposing the underlying features of different human practices. For example, take the way in which we eat. The practice of eating is given a structure by some simple distinctions that are to be found in various cultures. Thus in talking and thinking about food it is often important to recognize the conceptual difference between that which is raw as opposed to cooked, edible as opposed to inedible and native as opposed to foreign. It is through these pairs of opposing concepts (i.e., raw/cooked, edible/inedible, native/foreign) that we come to appreciate the structures that are often imposed on the way we eat.

The same can be said for other human activities. Take religion. Religion is given a structure via a different set of contrasting concepts. This time the concepts include: humans and gods, life and death, the sacred and the profane and good and evil. Once again, these concepts

CONCEPTUAL STRUCTURES

help in clarifying and making sense of not just some religious practices, but perhaps all of them. Also, such concepts help in understanding how religions need opposing forces for them to make sense to their believers.

The same approach can also be taken to clothing. The way that we think about clothing can be understood in terms of garments worn by men and women, by the distinction between formal wear and casual wear and via the contrast between parts of the body that a given culture thinks should be covered as opposed to uncovered. These pairs of concepts (i.e., men/women, formal/casual, covered/uncovered) help to give sense to what might at first appear to be diverse and inexplicable sets of cultural phenomena in the area of fashion.

Discussions of various opposing pairs of concepts that we find in the areas of food, religion and fashion are legion in the subject of semiotics. However, there are also pairs of more abstract philosophical concepts that apply to all manner of disciplines, subjects and cultures that are not discussed so often. These concepts include: truth and falsity, sameness and difference, wholes and parts, subjectivity and objectivity, appearance and reality, continuity and discontinuity, sense and reference, meaningful and meaningless and problem and solution. In this chapter we will have these concepts as our focus because, as we shall see, they govern different kinds of human thinking at a fundamental level.

IS THERE A PIPE IN THIS PAINTING?

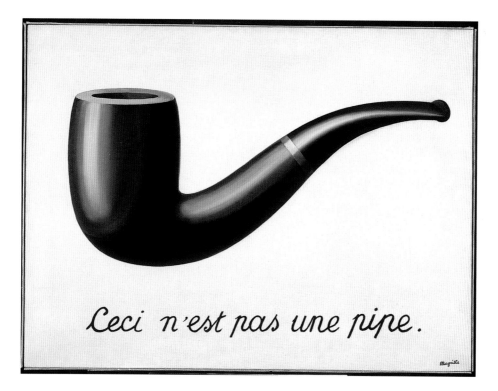

Ceci n'est pas une pipe.

IS THERE A PIPE IN THIS PAINTING?

In his famous picture *The Betrayal of Images ('This is not a pipe')* (1928–29), the Belgian artist René Magritte has written below an image of a pipe 'This is not a pipe' in French. But if this is not a pipe, then what is it? One obvious answer is that it is a painting of a pipe. A painting of a pipe is not a pipe, but only a way of representing a pipe. The same could be said of the word 'pipe'. The word 'pipe' is not a pipe either, but only a word that has the power to stand for the presence (or absence) of a pipe. Magritte's picture raises questions about the ability of images and language to represent or misrepresent the world itself. Through this picture we come to realize that truth and falsity are stranger concepts than we thought.

Truth and falsity are sufficiently curious that they cannot always be determined. This is particularly so in the world of fiction. Consider the following sentence: 'Hamlet had a wart on his nose.' Surely this sentence, like the painting by Magritte, represents the truth or it does not. So is it true or false that Hamlet had a wart on his nose? The problem that presents itself here is that nowhere in Shakespeare's play does it tell us whether Hamlet did or did not have a wart on his nose. Perhaps he did, or perhaps he didn't. We just don't know, and maybe Shakespeare himself did not know either. What this means is that there are some instances (and fiction is the most notable case) where talking of truth and falsity may make no sense.

If painting and other forms of representation are like the world of fiction then it may not be wise to talk about them in terms of truth and falsity. That said, however, it is still true to say that this image looks like a pipe (and it is false to say that it doesn't look like a pipe). The reason is simple. If it didn't look like a pipe it would be impossible to teach others – for example, children – that it did look like a pipe.

WHICH SHAPE IS DIFFERENT FROM THE REST?

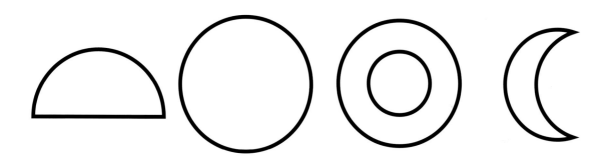

WHICH SHAPE IS DIFFERENT FROM THE REST?

There is actually no real reason for thinking one shape is different from the rest. It is only a matter of how we choose to perceive these shapes that may make us say that one is different from the others. For instance:

The first shape is the only one with a straight line.

The second shape is the only one that is truly basic.

The third shape is the only one that consists of two separate lines.

The fourth shape is the only one that looks as if it represents a familiar object (i.e., the moon).

Spotting differences is sometimes easy. At other times it is more difficult. Counterfeits, decoys, art forgeries, design replicas, fake currency, photocopies, reproductions, facsimiles, camouflage, instant replays, disguises, impersonators, identical twins and cloning are all things that raise questions for us about sameness and difference. (They also help to highlight the difference between something real and something that is merely a copy.)

There are two basic sorts of difference. One is a difference in *kind*, while the other is a difference in *degree*. Differences in kind are based on the fundamental sort of thing that we are talking about. For instance, while a person might look the same as a very realistic showroom dummy, these are fundamentally different kinds of thing. On the other hand, differences of degree occur when there are variations between things that may be very similar underneath. For example, the difference between a mountain and a molehill is only one of degree (nevertheless, the difference here is still large). There is also only a difference in degree between a genuine dollar bill and a forged one (this, though, may involve a very small difference).

The curious thing about sameness is that it is not as absolute as one might think. That is why we often need to ask: 'In what respect is x the same as y? Is it the same in respect of its shape, texture, colour, tone, material, use?' After all, it is only when x is the same as y in every respect that we don't really have any differences to speak of.

CAN YOU READ THIS?

Why deosn't the oredr of the ltteers in tihs qeusiton mttaer?

Why deosn't the oredr of the ltteers in tihs qeusiton mttaer?

CAN YOU READ THIS?

The oredr of the ltteers deosn't mttaer bcuseae we do not hvae to raed ervey lteter bferoe we can raed the wlohe wrod. The mian tihng is taht the frist and lsat ltteer are in the rghit pclae. The oethr ltteers can be in a toatl mdudle and you can sitll raed the snetnece wouthit a porbelm.

If we tend to see the whole word before we see its parts when we read, then what happens when we look at an image? We might assume that a portrait can only be a true likeness if the various parts of the face are considered carefully in relation to the whole. But some of Picasso's portraits demonstrate that even if you jumble up and distort the details of a face it can remain a good likeness. So maybe the look of the whole face is more important than the exact arrangement of its parts in portraiture.

Underlying these points about parts and wholes is a more general issue, which concerns the philosophical one of when we count something as a part and when we count it as a whole. The iris is *part* of a *whole* eye. An eye is *part* of a *whole* head. A head is *part* of a *whole* person. A person is *part* of a *whole* society. So eyes, heads and persons are both wholes and parts at the same time. What we see as a whole and what as a part, then, may depend on what we are trying to explain. If we want to understand how the eye works we will miss something if we look only at the iris. Similarly, we will leave something out if we try only to understand the eye in relation to the whole head. What is important is that we engage with the thing we are trying to explain at the right level. In doing this, though, we should not forget that the complexities of the world result from the fact that we can always divide a thing into its component parts or else look for other things that link with it to form a larger whole.

DO YOU SEE THE COLOUR RED IN THE SAME WAY AS OTHERS SEE IT?

DO YOU SEE THE COLOUR RED IN THE SAME WAY AS OTHERS SEE IT?

Some things appear to have a quality that is like nothing else:

The taste of coffee.

The smell of a rose.

The feel of fine-grained sand.

The sound of a bird singing.

The look of the colour red.

The qualities of our experience seem to be indefinable in some ways. For example, no matter how much we are told about the science of colour (i.e., about wavelength, purity and intensity, the colour-processing parts of the brain, different techniques of stimulation and problems such as colour blindness), we cannot say what it is like to have the experience of it. We can only say what the experience is like by having it. In this sense the experience of colour appears to be subjective (and personal) rather than objective (and scientific).

(As an experiment, ask yourself whether, if you had never had the experience, you could imagine what it would be like to taste coffee, smell a rose, feel sand, hear a bird sing or see the colour red.)

Though there is the subjective side to our experience of these qualities, there is also an objective side that can be tested by various scientific methods. The objective tests for colour do not concern what it is like to have the experience so much as the facts concerning what is perceived. These tests are particularly advanced in physiology and psychology. For example, there are tests that will help us to discover whether colour is variable or constant under a variety of viewing conditions, and how the colours that we perceive are dependent on the context in which they are placed (e.g., a colour may vary when it is placed next to other colours that are either similar or contrasting). All of these tests reveal something about the physiology and psychology of our perception. However, what they do not reveal – and this is the important point for semiotics – is just what these various colours (and other sensory qualities) actually mean to us.

DOES THIS BATTLE LOOK REAL?

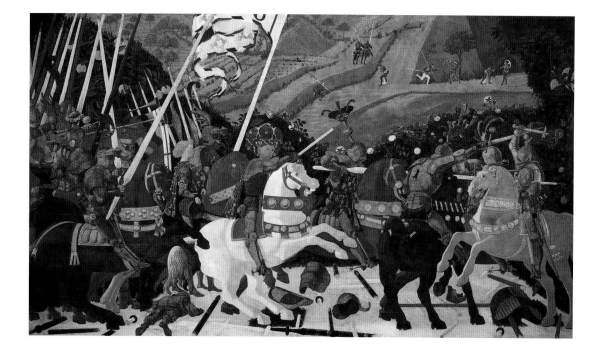

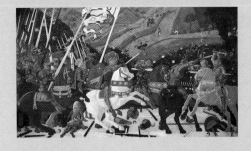

DOES THIS BATTLE LOOK REAL?

It is often said that the quasi-mathematical technique of linear perspective is the best system for representing visual reality. Developed, some have thought, by Filippo Brunelleschi, the early systems of perspective employed a series of lines that appeared to meet on the horizon at a single vanishing point. The results that were derived by using this system seemed real because they gave the impression of spatial recession and pictorial depth.

The fixed perspectival point of view that is offered to the viewer using this system is illustrated on the previous page in the work of Paolo Uccello in *Battle of San Romano* (c. 1435–60). This picture, by using the contrivance of lances placed on the ground, gives the viewer a series of visual cues that leads the eye from pictorial elements in the foreground of the picture (such as the central figure of Niccolò da Tolentino) to the background of the cultivated landscape with its tiny fighting figures. But does this device make the picture *real*, in the sense that we are presented with pictorial equivalents to the visual cues we find in 'normal' perception?

There are various problems with Uccello's picture as regards its verisimilitude. One problem is that the fixed viewpoint that Uccello gives us does not take account of the fact that in reality the eye is constantly moving in order to see objects in space. Another problem is that we see the world with two eyes, so creating a better representation of reality should actually involve a perspectival system that uses two vanishing points on the horizon so as to give more accurate up-hill and down-dale effects. A final problem is that perspective cannot be a substitute for the measurement of the objects that we see in space.

What Uccello's painting shows is that perspective, while it gives the impression of reality, is one pictorial contrivance that artists may find more or less useful in making images of the world. (Certain formal qualities such as line, tone, texture and colour can, of course, also contribute towards making a picture look realistic.) And even if there are some real-seeming elements to the picture that derive from the way perspective is used, it is still clear that nobody would mistake this for a real battle.

WHAT IS THE DIFFERENCE BETWEEN THESE TWO TIME-PIECES?

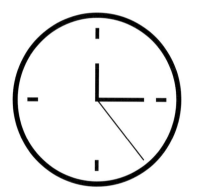

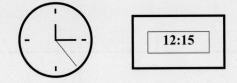

WHAT IS THE DIFFERENCE BETWEEN THESE TWO TIME-PIECES?

One answer is that the two time-pieces give different representations of continuity and discontinuity. The first thing to note is that the watch-face on the left represents time in analogue form, whereas the clock on the right represents it in digital form. This creates two different effects. With the watch-face we can see time passing as the hour, minute and second hands move round. Moreover, if we are timing something we may also see how much time has been used up and how much is left. However, with the clock there are only a number of quite sudden changes that happen. With a numerical display such as this we are only able to see exactly what time it is now.

The basic difference between the two forms of representation is that the analogue form of time (i.e., the watch-face) gives more of a sense of a continuum as the present is represented as having a relationship to the past and the future. With the digital form of time (i.e., the clock) there is an exact representation of the time in the present moment, but as there is a jump when the numbers change time can appear to be composed of units that seem discontinuous.

In general, analogue signs create relationships that are graded on a continuum. Examples are things that have a more/less quality, such as: visual images, physical gestures, facial expressions, bodily movements, textures, tastes and smells. These signs have a richness, complexity and continuity that cannot easily be expressed in another medium. On the other hand, digital signs have an either/or quality that can seem discontinuous because the categories used are unitized. Examples are things like the following conceptual oppositions: zero or one, off and on, this or that, black and white, light and dark, alive or dead. Notice in all of this, though, that analogue codes that have a flow, such as music, can sometimes be represented in digital form (e.g., on a compact disc).

WHAT DO YOU NOTICE ABOUT THE MAN DRINKING CHAMPAGNE?

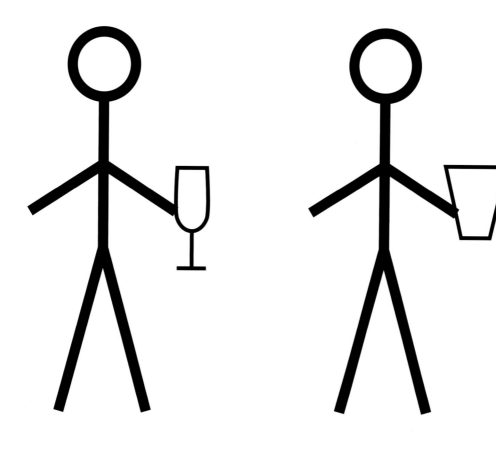

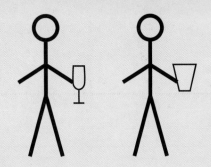

WHAT DO YOU NOTICE ABOUT THE MAN DRINKING CHAMPAGNE?

In asking about 'the man drinking champagne' it is easy to give the impression that we are referring to someone in a straightforward way. But perhaps the person that we think is the man drinking the champagne is, in fact, a woman. In this case there may be no person who is drinking champagne. Alternatively, it might be that the phrase 'the man drinking champagne' is inappropriate because the two people in question are just holding their glasses, but not actually drinking champagne from them. Another possibility is that we might have picked out the wrong person in using the phrase 'the man drinking champagne' because the man drinking champagne is using a beer glass (while his friend, who has the champagne glass, is actually drinking beer from it). Lastly, we might say that there is no man drinking champagne because both men are drinking a sparkling wine that is not champagne. One lesson here, then, is that just because we want to refer to something or someone, does not always ensure that we will succeed.

Reference is intriguing because you can refer to the same person or object in different ways. When I say 'the man drinking champagne' I intend to pick out a certain individual, but if I find that you don't know which person I mean then I could add, 'the man with the red jacket'. These descriptions, though different in sense, could have the same reference. The same point about co-referring terms can be made with the example of 'the morning star' and 'the evening star'. The phrases 'the morning star' and 'the evening star' clearly have different senses (or meanings), even though they refer to the same entity, namely Venus. Yet one might suddenly discover that the planet that I am referring to in one way (as 'the morning star') is the very same as the planet you are referring to in a quite different way (as 'the evening star').

The issues just discussed may make us consider how shifts in meaning or reference can serve to undermine or compromise our ability to communicate clearly and unambiguously with one another about all manner of things that we take for granted in the world.

DO THESE TRAFFIC LIGHTS MAKE SENSE?

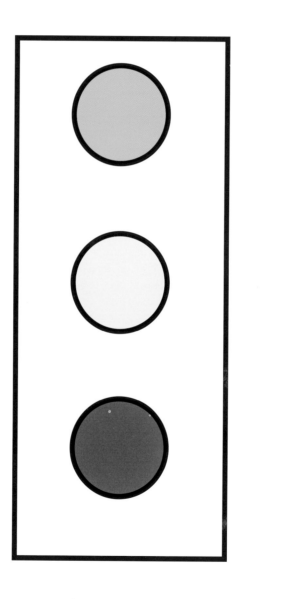

DO THESE TRAFFIC LIGHTS MAKE SENSE?

In the traffic light system that is used in many parts of the world we assign a meaning to each of three coloured lights: red, yellow and green. For drivers using this system the lights have the following meanings:

Signifiers:	Red	Yellow	Green
Signifieds:	Stop	Caution	Go

What these lights mean can seem obvious if you are already familiar with them. Their meanings, though, depend on a number of underlying assumptions. The first is that we each have the ability to distinguish the colour concepts *red*, *yellow* and *green* from one another (this is not an assumption that we might want to make about people that are colour blind). The second is that we understand the meaning that each coloured light has in the cultures that employ this system (and this is a matter of an established convention that other cultures may not immediately appreciate). The third is that we understand how and why the lights themselves form part of a larger system of road signs (and this, again, depends on specific cultural knowledge that one might have about the country one is driving in).

The meaning of each light is arbitrary if only in the sense that the following combination could still have worked to control traffic had it been agreed upon by the culture in question:

Signifiers:	Yellow	Green	Red
Signifieds:	Stop	Caution	Go

The reason this alternative system could work equally well (and be equally meaningful) is, first, that each colour is visually distinct and, secondly, that each colour can be assigned a specific meaning within the traffic light system.

Now think what would happen if traffic lights were structured using the following colours:

Signifiers:	Orange	Red/Orange	Red
Signifieds:	Stop	Caution	Go

This would result in confusion, not because the lights are set out in the wrong way, and not because the lights would be intrinsically meaningless, but because human beings find it hard to see the difference between orange and red/orange and red and red/orange by using the concepts that they have. And this would result in confusion about their meaning, even if it did not render them meaningless.

CAN YOU CROSS THROUGH ALL NINE DOTS USING ONLY FOUR STRAIGHT LINES WITHOUT LIFTING YOUR PEN FROM THE PAPER?

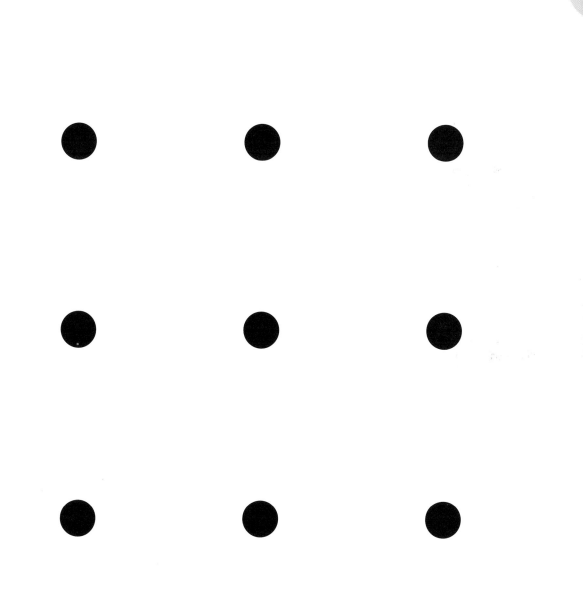

CAN YOU CROSS THROUGH ALL NINE DOTS USING ONLY FOUR STRAIGHT LINES WITHOUT LIFTING YOUR PEN FROM THE PAPER?

The nine-dot problem is often used to illustrate how our thinking can get stuck. This happens because the tendency is to think within the box shape that the nine dots seem to create. However, when you step outside this constraint a solution suggests itself. One solution is given below:

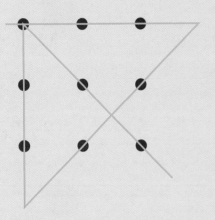

Once this solution has been seen the tendency is to stop searching for alternatives. Yet there are many others. You could draw through the dots with a pencil that has a tip wider than the box shape itself. You could cut the dots up and put them in a line and then draw through them. You could fold the paper so that you have a small square with all the dots lined up behind one another and push a pencil through them. In other words, each problem may have many solutions.

When we face a difficult problem we often search long and hard for a solution. The history of pictorial representation demonstrates this. Painters thought for a long time that pictures could develop in such a way as to become more true to life. But the problem with any representational medium – whether paint or language – is that it can only stand in different ways (using different signs) for the things that are represented. And because paint and language are not (and can never be) reality they will always fall short of reality. Thus the underlying assumption that we should search for the perfect medium of representation that can mirror reality must be mistaken.

One overall philosophical difficulty we face is that while some problems have one solution and others have many solutions, some problems have no solutions, and some problems are not even problems. The problem, then, is often in telling what sort of problem we have.

VISUAL STRUCTURES

Objects, images and texts are given structure though composition. Composition has two dimensions: space and time.

Space, or the spatial aspect of any composition, has two factors: placement and presence. Take, as an example of placement, the different elements in picture-making. Placing something at the top of a picture tends to idealize it, whereas placing something at the bottom can make it seem more down-to-earth and realistic. That is why God needs to be placed above humans in a painting (and humans need to be placed below God). Placing something on the left of a picture tends to indicate that which has been assumed, whereas putting something on the right tends to indicate that which is new. Books on dieting show this by placing a 'before' image of someone who wants to lose weight on the left side of a page along with an 'after' image of them having successfully lost weight on the right side. Placing something in the middle of a picture tends to give it

prominence over something placed in the margin. In maps of the world, individual countries can be rotated so that they are in the centre and others are on the periphery, which can make them appear dominant. And placing something in the foreground of a picture can give it importance in a way that placing it in the background could not. An instance of this phenomenon is the self-portrait, in which the sitter tends to dominate his surroundings.

Presence, in contrast, is created by employing the following sorts of elements in making a picture: proximity (together/apart), balance (symmetry/ asymmetry), number (many/few), size (large/small), colour (bright/dull), contrast (high/low), detail (fine/ course), tone (light/dark), shape (regular/irregular), texture (rough/smooth), time (static/moving) and arrangement (organized/ disorganized). These elements, depending on the context in which they are used, will help to draw attention to, or away from,

VISUAL STRUCTURES

different parts of the composition by providing various kinds of emphasis.

Time, or the temporal aspect of composition, has, in common with the spatial dimension, two factors: placement and presence. Temporal placing is about whether some feature is placed before or after another in a sequence. The notions of 'before' and 'after' are typically used in such things as cartoons, sequential diagrams and paintings of changing moments. Temporal presence, on the other hand, is about whether something is shown as situated in the past, present or future. For example, history of art lectures can reveal the attitudes of past cultures, books on contemporary design can tell us about the stylistic tendencies of the present and exhibitions about

technological innovations can help us to speculate on the future. Such things as lectures, books and exhibitions help to give objects, images and texts the qualities of pastness, presentness or futureness in the way that they are shown. In addition, the qualities of fastness and slowness, where evident, can count as forms of temporal presence. The pace of time can be indicated by such things as the patina of an object, by blurring in a photograph or by the crystallization of a transient moment in a painting.

The key concepts to be discussed in this chapter will therefore be: viewer and image; ideal and real; given and new; centre and margin; foreground and background; proximity and presence; before and after; past, present and future; and fast and slow.

WHAT DOES THIS IMAGE REPRESENT?

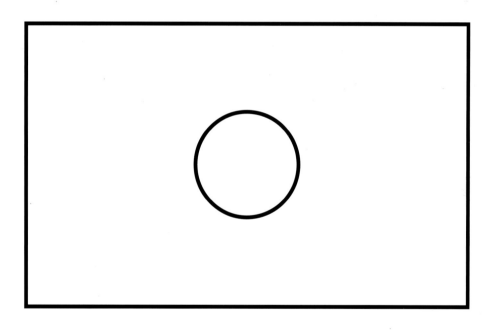

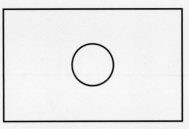

WHAT DOES THIS IMAGE REPRESENT?

Assuming that this is a highly simplified picture, there are various possibilities. It could be:

1. A hole in a wall
2. A circle drawn on a wall
3. A circular piece of tube fixed to a wall

Notice that what you actually see does not change in each of these three descriptions. What changes is the way that you interpret what you see. In the first instance, we see through a wall. In the second instance, we look on to a wall. In the third instance, an object comes out from a wall. What is worthy of note are the changes in the way that we see the image but also the fixed position of the viewer. Here the viewer is assumed to be looking across at the image in each case.

But now imagine that you are not looking at a wall, but at a table. Here are three more interpretations. It could be:

4. A hole in a table
5. A circle drawn on a table
6. A circular piece of tube fixed to a table

Again, the content of the image is the same but the notional position of the viewer has changed through the description given. Now the viewer is looking down instead of across.

Now we imagine we are looking at a ceiling. Here are three further interpretations. It could be:

7. A hole in a ceiling
8. A circle drawn on a ceiling
9. A circular piece of tube fixed to a ceiling

Once more, the content of the image is the same but the notional position of the viewer has changed again. This time the viewer is looking up. (Alternatively, of course, the viewer might be looking down through the hole in the ceiling from above.)

What these nine interpretations demonstrate is that the image and viewer positions can change via new descriptions. It is this constant negotiation and shift between viewer and image, then, that is vital to understanding these sorts of visual structures and our interpretations (and reinterpretations) of them.

WHICH PART OF THIS PICTURE IS IDEALIZED?

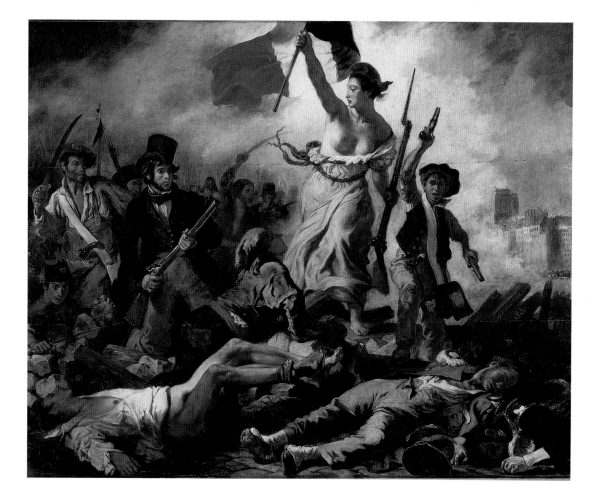

WHICH PART OF THIS PICTURE IS IDEALIZED?

Pictures can be divided in different ways. One way to divide them is to place the idealized elements at the top of the picture and the realistic elements at the bottom. Eugène Delacroix's *The 28th July: Liberty Leading the People* (1830) illustrates this point. Liberty, who in this instance is symbolized by the female figure carrying the flag, is placed at the top and centre so that attention is drawn to her importance. Below her reside figures that are at once symbolic of the people as a whole, but at the same time somehow more realistic in terms of their depiction. In this way 'the people' are shown to be aspiring to the ideal of liberty that is placed literally above them. So, while both Liberty herself and the people below her are idealized, the intention seems to be to make the latter group seem more real, with the ultimate reality of death – which is the consequence of the removal of the ideal of liberty itself – appearing at the very bottom of the image.

The same visual structures are to be found in magazine advertising. In an advert for a certain kind of food we will typically find an idealized image at the top of the page with an indication of the reality of the product being sold at the bottom. For instance, there might be a photograph of a gleaming bunch of succulent looking grapes at the top of the image. Below this we might find that what is being advertised is dried fruit. In such an advert the viewer is reminded of the difference between the ideal (the gleaming fruit) and the corresponding reality (its dried counterpart). But by linking the two it is hoped that the consumer will see how the former might have been condensed into the latter. In other words, the advert, by linking the real with the ideal, indicates the nature of our aspirations to move constantly from what is the case (the real product) to what could be the case (the ideal product).

IS IT BEST TO READ THIS IMAGE FROM LEFT TO RIGHT OR RIGHT TO LEFT?

IS IT BEST TO READ THIS IMAGE FROM LEFT TO RIGHT OR RIGHT TO LEFT?

This image, taken from the Bayeux Tapestry, which chronicles the Norman conquest of England by William the Conqueror in 1066, should be read from left to right. But how do we know that? One answer is that the horses, although they are frozen in the picture, appear in the main to be travelling in that direction. So maybe there is a clue in the picture itself. More important than this, though, there is the standard convention that reading the image from left to right is simply correct.

It is easy to think that everyone reads from left to right. Of course, in Western cultures this is true. That is why a Western advert for a washing powder will have a picture of a soiled garment placed on the left and an image of a pristine garment placed on the right. By placing the images in this order the reader knows that the washing powder will help dirty clothes to become clean. However, audiences in the Middle East, who read from right to left, will read the advert in the opposite way. It will seem to them as though the washing powder is taking gleaming white clothes and turning them a dirty grey. Thus the meanings we discern when we employ the convention of reading from left to right are actually specific to a given culture and context.

Whether we read from left to right or from right to left, it seems true to say that the information placed on one side of a composition is usually 'given' or assumed, while the information on the other side tends to be 'new' or unexpected. So in the advert just imagined, the 'given' information is that clothes get dirty (this appears on the left in Western cultures). The new information is that the particular washing powder that is being advertised is good at getting clothes clean (this appears on the right in Western cultures).

WHY IS CHRIST PLACED IN THE CENTRE OF THIS SCULPTURE?

WHY IS CHRIST PLACED IN THE CENTRE OF THIS SCULPTURE?

The idea of a centre is important to many human activities and to much human thinking. The universe has a centre. The world has a centre. Countries have centres. Cities have centres. People have centres. Even our nervous system has a centre. And objects, images and pieces of text have centres too.

Centres provide a focus. Centres are important and vital. They act as hubs around which other things are positioned, or else they provide a stable point from which other things might circulate. The centre can also be the thing that is seen to prevail over that which surrounds it. With centres, though, come margins. Margins are on the outside. Margins provide limits, edges, borders and boundaries. Margins, in contrast, can be viewed in some ways as overridden by their centres.

We tend to think of something placed in the centre of a composition as having importance and higher status. This is in contrast to those things placed on the margins, which tend to have less importance and lower status. In the *Deposition* (or *Florentine Pietà*) by Michelangelo (1550–53), pictured on the previous page, we see the significance of the centre and of the relative insignificance of margins. The sculpture includes four figures: Christ, Nicodemus, Mary Magdalene and an incomplete figure. In the sculpture Michelangelo has clearly placed Christ in the centre, surrounding him with the other figures who envelop and support him. So although the other figures are physically close to him, they are still on the margins. In this sculpture, then, the concepts of *centre* and *margin*, combined with the concepts of *in front* and *behind*, act to contrast the idea of permanence and significance (Christ) with transience and relative insignificance (Nicodemus, Mary Magdalene and the incomplete figure).

What is interesting about this sculpture is that it presupposes a position for the viewer. (In this instance, we view the sculpture as having a front, back and sides.) And so, as was the case with the images we discussed earlier, we should not try to see the positioning of three-dimensional objects in isolation from the positioning of the person who sees them.

WHAT DO YOU NOTICE ABOUT THE BACKGROUND OF THIS IMAGE?

WHAT DO YOU NOTICE ABOUT THE BACKGROUND OF THIS IMAGE?

Human beings have the ability to perceive things in terms of foreground and background. Take objects that are placed on a table. Here we immediately become aware of the objects themselves (which are seen as being in the foreground) rather than the spaces that surround them on the table (which are seen as being in the background). Take music that is being listened to on headphones. Here the melody of the tune is the usual subject of our focus (which is in the foreground) rather than the tracks that make up the rest of the music (which often seem to be in the background). Consider a printed page. In seeing such a page we will tend first to dwell on the text (which is in the foreground) rather than the spaces that surround the text (which may be considered as a mere background).

M.C. Escher, in his picture *Mosaic II* (1957), demonstrates some of the paradoxes of foreground and background. Curious is his suggestion that what we regard as foreground and as background is in some ways a matter of choice. For in his image our focus can change so that that which is usually seen as the foreground can be viewed as the background, and vice versa. Even though a perceptual switch can occur so that what we see first as foreground can suddenly become regarded as background, we still need to appreciate that this switch does not happen very often (unless it is brought about deliberately, as in Escher's picture). When you see certain things as being in the foreground, other things tend to form a background and in this way become unseen or go unnoticed.

CAN YOU IDENTIFY ONE GROUP OF TWO STARS AND ONE GROUP OF THREE STARS?

☆☆☆ ☆☆

CAN YOU IDENTIFY ONE GROUP OF TWO STARS AND ONE GROUP OF THREE STARS?

Often we group things together because of their proximity. Things that are placed near one another tend to be grouped together. On the other hand, things that are placed apart from one another we tend to think of as separate. The fact of proximity might be one reason we might want to group two black stars and a red star together to make up a group of three, and one black star and a red star together to make up a group of two. Placing things in images in a certain way, or presenting objects in a certain way, then, is important if you want to draw attention to them – or divert attention away from them.

The other obvious way of grouping these stars is by colour. This, in contrast, is about the presence or aura that they have. To group them in this way means putting the black stars in a group of three and the red stars in a group of two. Presence can be indicated in different ways by such things as size, colour, sharpness, tone and texture. Size is usually indicative of importance and authority (e.g., the Statue of Liberty). Colour is often essential for creating naturalism or indicating that naturalism is absent (e.g., over-enhancing colour can make an image or object seem dreamlike or fake, whereas removing colour can make it seem nostalgic). Sharpness – at least as it applies to images and texts – can make something appear more believable, whereas a lack of it can make something appear inauthentic or vague (e.g., a soft-focus photograph might be used to indicate a hazy memory). Contrast in terms of tone can create drama, but without it the impression may be one of drabness or lack of commitment (e.g., notice how spectacular the stark contrast of black-and-white can be in Film Noir). Texture can be tactile and warm, but it may imply imperfection; its absence can be cold and indicate flawlessness (e.g., an engaged drawing of the texture of human skin may give a quite different impression to a detached biological diagram of human skin).

WHY DO THE FIGURES ON THE FAR RIGHT OF THE PICTURE APPEAR MORE THAN ONCE?

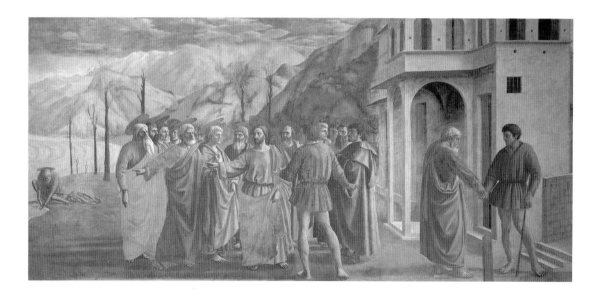

WHY DO THE FIGURES ON THE FAR RIGHT OF THE PICTURE APPEAR MORE THAN ONCE?

In this painting, *Tribute Money* (1426–28), Masaccio produces a narrative with three scenes. The composition is curious because the three distinct events are placed next to each other in the picture in such a way that they might not immediately appear to be separate.

The story of the Tribute Money, which is based on an account given in St. Matthew's Gospel, involves Christ, St. Peter, other apostles and a tax-collector. In this instance, Christ is seen in the centre of the picture with the apostles explaining that he has been asked for his taxes to be paid. Christ then invites St. Peter to perform the task, but at the same time tells him where he can find the money. On the left of the picture we see St. Peter catching a fish and removing a gold coin from its mouth. And on the right we see St. Peter giving the tax-collector the money that is owed.

What is odd about this painting is that the viewer has a sense of the order of the scenes even though they do not conform to the pictorial structure that we might expect. This is because there is a conflict between two demands that we have already discussed in this chapter. The first is that the most important figure should normally be placed roughly in the centre of the image, and second is that we tend to read visual images from left to right. What this image demonstrates, then, is that even though we might have a standard way of representing 'before and after' sequences visually, we can also deviate from it. What we need to ensure, though, is that when we do deviate from standard conventions those who try to read them appreciate how they have changed. Otherwise, the result of a change in convention can be a drift into incomprehension.

CAN WE IMAGINE THE FUTURE?

CAN WE IMAGINE THE FUTURE?

Time is important in semiotics because we think of ourselves in relation to its flow and because we are apt to make judgements about it. For example, we can often regard past things as quaint, nostalgic, amusing, charming or simply archaic, present things as exciting (and sometimes boring), and future things as new, ambitious, avant-garde or simply frightening. The need to speculate about the past, question the present and predict the future seems somehow to be built into the chromosomes of human beings.

If we view time as composed of the linear and discrete elements of past, present and future, then it would seem to follow that we can think of things as being ahead of the times or behind the times. And this is where our thinking about objects, images and texts starts to become structured and composed by time. For we often talk about a work (say, a product, painting or book) as being 'ahead of the times', 'of its time', or 'behind the times'. But what, more exactly, do we mean when we talk in this way? In what sense can such things really, say, be *ahead* of the times, as opposed to simply *of* the times in which they actually exist? And if it is genuinely possible for a work to be futuristic, how long can it stay out in front? How long will it be before other works catch up?

In this image of the future from Fritz Lang's film *Metropolis* of 1926, we find a picture of a strange-looking metropolis. This raises some of the questions we have already asked, but in a visual form. Is this image suggestive in allowing us to imagine what might have happened to make such a futuristic city possible? Or does it only serve to confirm the thought that a 1920s' view of the future will be nothing more than a 1920s' view of the future?

CAN WE REPRESENT TIME?

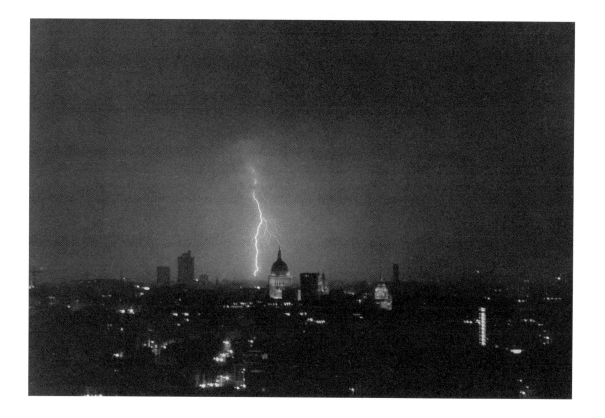

CAN WE REPRESENT TIME?

Objects, images and texts have different forms of temporal flow. This flow can be represented in numerous ways. The flow of an object can be thought about in relation to its life-cycle and in relation to how it is used during that life-cycle (e.g., the walking stick is designed for a life of slowness whereas the motorbike is an emblem of speed and seems intended for a life of haste). The flow of an image may be exemplified by how different movements of time and moments in time can be represented in different media (e.g., a painted image may capture a fleeting smile, or the juxtaposition of multiple images in a film may show the speed of a horse running). The flow of text may be about how it is placed with other texts, how it is spaced, and what sort of graphic and auditory features it has (e.g., slow, long sentences may be evident in a play, whereas quick, short syllables may be evident in a poem).

Slowness can be contemplative, spiritual, sluggish, boring, leisurely, measured or relaxed. A still-life painting may be motionless and may make the viewer pause for thought. A children's book can repeat itself constantly and may appear slow and boring to an adult. A poem may be meditative, making us dwell on a single moment in time. Fastness, on the other hand, can be exciting, vital, energetic, inspiring, dangerous and stirring. A fast car chase in a film may be exciting (e.g., the chase in the Steve McQueen film *Bullet*). A painting that has been created with a fast-moving brush can appear vital (e.g., the work of Jackson Pollock). A piece of music that is played at speed can be inspiring (e.g., Count Basie's *Shout and Feel It*).

The question as to whether we can represent time may be misleading; that is, if we think of the question as being about how to depict the phenomenon of time. This is because there are so many ways that something that takes up time can be represented, none of which may be 'true' to the way we experience time itself. (Indeed, we may wonder whether we do experience time at all.) In photographing a flash of lightning (which takes but a small moment of time) we may find that we have translated the experience and quality of fastness into the experience and quality of slowness. What happens by making such a photograph, then, is that something of the temporal aspects of lightning are lost (but also, at the same time, gained).

TEXTUAL STRUCTURES

As a universal medium of communication, human language makes us different from other animals. Just how different can be gleaned from the fact that the average reading vocabulary of a human – at least in the Western world – is around 40,000 words, whereas even the most intelligent ape that has been taught a language-like system of communication can muster only about 400 signs in total.

Natural language, which enables human beings to have highly sophisticated thoughts, has an orderly structure. One part of the structure is called 'syntax', whilst the other part is called 'semantics'. The syntax of language tells us when a sentence has been constructed in a fashion that is grammatically correct and when it has been constructed in a way that isn't. Semantics, on the other hand, is about what the sentences we construct by using various grammatical rules actually mean. Although the grammatical rules

for constructing sentences and the meanings that they can create are conceptually distinct, in practice they operate together. What is more, the rules and meanings of a language are, in turn, to be understood not in isolation, but in relation to the role that they play in various contexts, only some of which are linguistic.

Of interest to semioticians are not just the meanings that arise from language, but rather more the relationships that can exist between language and the various images and objects with which it may interact. Even if we consider just the meanings that can be generated between texts, images and objects, we would have to engage in an analysis of some of the following features that should be thought of as integrated wholes for the purposes of analysis:

- The form of the text. This consists of the shape and colour of the letters and the layout of the words.

TEXTUAL STRUCTURES

- The content of the text. This consists of the meaning of the words and their reference (if they have one).

- The form of the image. This consists of the various structures (composition and framing), pictorial devices (perspective and forms of distortion) and formal elements (colour, tone and line) that organize the image.

- The content of the image. This consists of what the image is of: a cat, a car, a chair, a house, a person, a country.

- The form of the object. This consists of the various structures (composition and orientation), shape devices (the front and back, top and bottom, right and left sides – and even perhaps the underside – that are often perceived as distinct aspects of the object) and formal elements (colour, texture and material) that are part of the physical make-up and experience of the object.

- The content of the object. This consists of what the object is: a sculpture, a product, a building or a piece of clothing.

Some of the aspects of text that we will have occasion to explore in this chapter will concern the roles of the following: readers and texts, words and images, functions, forms, placing, prominence, voices, intertexuality and intratextuality, and paratext and paralanguage.

WHAT IS CURIOUS ABOUT THIS POSTCARD?

Dear Mr Barthes,

Thank you for helping
me to cope with the real terror
of trying to understand
the margins of your
philosophy.

Yours sincerely,
Jacques.

Dear Mr Barthes,

Thank you for helping me to cope with the real terror of trying to understand the margins of your philosophy.

Yours sincerely,
Jacques.

WHAT IS CURIOUS ABOUT THIS POSTCARD?

There are many ways to write a text. There are also many ways to read one. When readers read a text they often make very different assumptions about it. Some of the standard assumptions that are made in reading texts are listed below under the heading of 'structuralism'. This structuralist list reminds us that we often analyze the meanings of a text in terms that will give it a unity and overall sense. Now compare these assumptions with those of the post-structuralist (which are also listed below). In contrast, the post-structuralist embraces the idea that a text may not be coherent and may not make any sense overall.

Structuralism	Post-structuralism
Consistency	Inconsistency
Balance	Imbalance
Harmony	Disharmony
Unity	Disunity
Coherence	Incoherence
Completeness	Incompleteness
Resolution	Conflict
Presence	Absence
Belief	Paradox
Actions	Omissions
Stability	Instability
Reliability	Unreliability
Non-contradiction	Contradiction
Linearity	Non-linearity
Fixed viewpoint	Flexible viewpoint
Foreground	Background
Sense	Nonsense
Perfection	Imperfection
Regularity	Irregularity

Notice that both structuralist and post-structuralist concepts can be used for the interpretation of images and objects just as much as for texts. For instance, instead of attending to the foreground of an image to find its meanings (which might happen if we are structuralists), we may look more at its background to find its meanings (which might happen if we are post-structuralists). Rather than examine the qualities of an object that make it reliable (which we might do if we are structuralists), we may shift this emphasis and try to examine the qualities that make it unreliable (which we might do if we are post-structuralists).

In the light of the structuralist and post-structuralist concepts listed above, there are at least two ways to read and understand the postcard on the previous page. We could see it as a genuine postcard. This would mean trying to make complete sense of it. Or else, we might see it as a playful form of nonsense, where there is no stable meaning to which the reader might gain access. In fact, the postcard, which purports to be from Jacques (Derrida) to Roland (Barthes) is intended to be playful in the way it refers to the work of those two authors.

WHICH TEXT IS TELLING THE TRUTH?

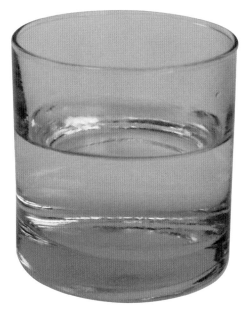

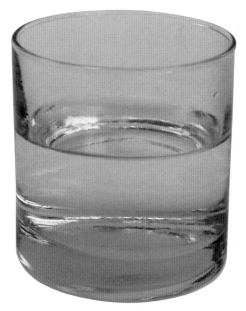

POISON

HOLY WATER

POISON **HOLY WATER**

WHICH TEXT IS TELLING THE TRUTH?

To understand some of the numerous interactions that can occur between words and images one might first consider books that have no text. In books for small children that have pictures but no writing parents are forced to make up large parts of the story. This gives a great deal of control to the reader. In this instance, the reader becomes a key locus for the reading of the book. Now, in contrast, consider a text without pictures or illustrations of any kind, such as a novel. In this case, as there is no visual guidance, we have to rely on textual descriptions in order to know what the characters or places in the novel look like.

Images on their own are often so open to interpretation that they fail to provide a stable meaning for the reader to grasp. This may be why we might need to supplement them with words. Words help to reduce the number of interpretations available. Words aid us in anchoring images. (Just how important it is to anchor an image properly can be seen from the picture on the previous page. For it obviously matters greatly whether a glass turns out to contain poison rather than holy water.)

The problem of open interpretation occurs with texts too. And this is where illustration comes in. For example, Sir John Tenniel's illustrations for Lewis Carroll's *Alice in Wonderland* help to elaborate on, and ground, what is to be found in the text in such a powerful way that people think that Alice really is blond when, in fact, Carroll does not actually specify the colour of her hair in the book.

Pieces of text, then, can simplify, complicate, elaborate, amplify, confirm, contradict, deny, restate or help to define different sorts of meanings when they interact with images and objects. This can occur in cartoon strips, in photographs with captions, in maps with place names, in adverts with overlapping text, in flat-pack furniture with instructions or in the case of sculptures that have written provenances.

DO YOU KNOW WHAT I MEAN?

'What is't thou say'st?'

'What is't thou say'st?'

'What is't thou say'st?'

'What is't thou say'st?'

'What is't thou say'st?'

'What is't thou say'st?'

'What is't thou say'st?'

'What is't thou say'st?'

'What is't thou say'st?'

'What is't thou say'st?'

'What is't thou say'st?'

DO YOU KNOW WHAT I MEAN?

The meanings of words or sentences depend on the function they play in a language. Here are a number of different ways in which the words 'What is't thou say'st?' and 'Do you know what I mean?' might function.

Emotive function. As producers of communication we often reveal things about our emotions (e.g., hopes, fears and feelings), our attitudes (e.g., beliefs, desires and thoughts) and our age, status, gender, race or class. By saying, 'Do you know what I mean?' in an anxious way someone may indicate that they are nervous about their ability to communicate clearly. When language reveals some personal characteristic in this way it has an emotive function.

Conative function. Communication will always have an effect on the people or persons receiving it. In this instance, someone who says, 'Do you know what I mean?' all the time may simply bring about a feeling of irritation in the listener.

Referential function. When we utter the words 'What is't thou say'st?', the words themselves may not matter. What may matter instead is how the words are used to create a particular form of reference. In this instance, they may refer to the language of Shakespeare, which is where they come from.

Poetic function. The poetic function is not so much about poetry as about the creativity or aesthetics of language use. So one difference between 'What are you saying?' and 'What is't thou say'st?' is that the latter form of expression seems to have an aesthetic quality that the former form of expression does not.

Phatic function. In using the phrase 'Do you know what I mean?', we could be saying 'Are you listening to me?' In this instance, the content of the communication is redundant because the purpose is simply to keep the channels of communication open. When you want to maintain or establish communication with someone else, language can be used in a phatic mode to get attention.

Metalingual function. Sometimes we need to make sure communication is working properly. For example, if you are giving important instructions you may need to ask, 'Do you know what I mean?' afterwards. In saying this, the content of what you say matters because you are checking to see whether what has been said has been fully understood. In this case, the question has what we call a metalingual function.

DO YOU NOTICE ANYTHING ODD ABOUT THIS ADVERTISEMENT?

ADVERTISEMENT

Dear Reader,

Here is a list of 37 works of art that I really must make before I die.

Make drawings of things that people keep under the bed
Arrange postcards of Carl Andre's *Equivalent VIII* in the shape of Carl Andre's *Equivalent VIII*
Produce a Rorschach ink blot that resembles the face of Rorschach himself
Set up a camera inside a fridge so that it takes a photograph of every person who opens it
Bet that gallery-owner Charles Saatchi will buy a betting slip that I have taken out about him
Paint a portrait of the writer G_org_s P_r_c and make it into a jigsaw puzzle
Design an ironing-board cover with a reproduction of a Rembrandt on it
Photograph lots of ears
Try to make a film about peripheral vision
Produce a piece of work that can be worn in the snow
Place a Turner reproduction in direct sunlight until it fades to white
Sell the copyright to all the works that I will produce in the year 2020
Invent a series of fictional art quotes
Have a show of different images that are all painted in red
Purchase a personalized number-plate with the word 'concept' on it
Take Freud's *Interpretation of Dreams* and run it through a spell-check
Write a piece in braille about blindness and put it behind glass
Imagine what Yves Klein yellow would look like and then paint a canvas in that colour
Enter a picture into an exhibition under a pseudonym
Redraw the picture by Willem De Kooning that Robert Rauschenberg once erased
Use sign language to describe a fictitious artwork
Print a series of erratum slips to put into books I would like to subvert
Copy my earliest drawing
Produce a short video of the television turned up as loud as it will go
Construct a flick-book of Marcel Duchamp saying the word 'art'
Film the testing of an umbrella in a wind tunnel
Write a book on semiotics that has advertisements for my own work in it
Erase images from children's books with correction fluid
Commission an advertising agency to think of ten prophecies for the future and then make a print of them
Sell my own art gift vouchers
Put all the works of art I have ever made into one big room
Build a Y-shaped coffin
Take snap-shots of people looking at the *Mona Lisa*
Specify 100 titles for works of art that sound strange or bizarre
Fill a sketch-book while taking a trip in a submarine
Do a detailed drawing of everything I throw away during the period of one week
Write a letter to a fictional character with a fictional address

Yours faithfully,

The Author

DO YOU NOTICE ANYTHING ODD ABOUT THIS ADVERTISEMENT?

Different relationships can be constructed between writers and readers – and speakers and listeners – by using different linguistic forms. Some of the many forms that speech and writing can take are listed below:

- Formal Writing: academic essays, legal forms, menus, instructions, medical reports, text books, memoranda, manifestoes

- Informal Writing: personal letters, e-mails, postcards

- Formal Speech: political speeches, scripted performances, academic lectures

- Informal Speech: casual conversations, improvised performances, practical seminars

Although these forms of speech and writing are often distinct, they sometimes converge. Converging forms are often employed by advertisers to create different kinds of relationships with consumers. Sometimes an advert will take the form of a letter. If such a letter uses a personal form, then this may help create a false feeling of intimacy between the advertiser and the person reading it. This false feeling of intimacy may be effective in disarming the reader. And this in turn may make the reader susceptible to the message that the advertiser is trying to convey.

In the text on the previous page I have used a number of conflicting formats. We are told at the top that it is an advert, but it also appears to be a letter in certain respects. It also has certain characteristics of a manifesto. At the same time the words 'Dear Reader' and 'The Author' appear on this notional page, which makes it look as though there is a recognition of the fact that the text in the box is being produced in the context of something else (for example, a book on semiotics). By combining various familiar written forms that usually have a definite structure, meanings may start to become opaque. However, by challenging existing linguistic structures there are still some advantages. One is that new meanings may evolve.

It may be of interest to note that the author is producing a limited number of prints from the piece on the previous page that will be sold independently as artworks.

WHICH PERSON DO YOU LIKE BETTER?

--

George Eliot is cheerful, conscientious, spontaneous, critical, obstinate and jealous.

--

Mary Ann Evans is jealous, obstinate, critical, spontaneous, conscientious and cheerful.

--

```
--------------------------------
George Eliot is cheerful,
conscientious, spontaneous,
critical, obstinate and jealous.
--------------------------------
Mary Ann Evans is jealous,
obstinate, critical, spontaneous,
conscientious and cheerful.
--------------------------------
```

WHICH PERSON DO YOU LIKE BETTER?

Even though the descriptions are the same, the judgements we make about these people may depend on the order of the words used. Our attitudes in such cases result from what are called 'serial position effects'. If you preferred George Eliot to Mary Ann Evans then that may be because the qualities listed at the start are easier to recall – because they are held for longer in our working memory – and hence they tend to have more impact on our thinking. This is sometimes referred to as the 'primacy effect'. (It could be that certain clichés and stereotypes about women – namely, that they are likely to be more jealous and critical than men – could also influence us in a negative fashion in this instance.)

Our willingness to play with the placing of words and letters to create new and novel meanings is evident from many games and pastimes, from the crossword to the anagram or the palindrome. One way to generate new meanings is to splice two words together. For example, if we choose to splice the word 'internet' with the word 'intellectual' then we generate the new portmanteau word 'internetual'. Having done that, we might seek a meaning for this word. In this case, the word 'internetual' might refer to somebody whose, perhaps false, intelligence is gleaned exclusively from the internet.

The placing of words in a new or novel order may sometimes have the effect of shocking or surprising us. The method of cut-and-paste poetry is an example. This way of making poems was popular with the group of artists know as the Dadaists. One of them, Tristan Tzara, suggested that one method of making a poem was to find a newspaper and, having cut it up, to shuffle the pieces in a bag before drawing them out at random and making a note of the order in which they had been drawn, along with their content.

READ THE FOLLOWING LIST OF WORDS ONCE AND THEN TURN THE PAGE:

word
quest?on
banana
evil
sdrawkcab
live
ghoti
enough
women
ration
fish
laughter
daughter
I
Want
To
Be
Like
You
buy
repetition
repetition
man
ate
net
subtra_t
memory
Leslie Welch
supercalifragilisticexpialidociouslyantidisestablishmentarianismist
wrong
games

word
quest?on
banana
evil
sdrawkcab
live
ghoti
enough
women
ration
fish
laughter
daughter
I
Want
To
Be
Like
You
buy
repetition
repetition
man
ate
net
subtra_t
memory
Leslie Welch
supercalifragilisticexpialidociouslyantidisestablishmentarianismist
repeating
games

READ THE FOLLOWING LIST OF WORDS ONCE AND THEN TURN THE PAGE:

Try to remember as many of the words you have just read as possible. Which words did you remember? Which words seemed most prominent to you? Ask yourself why this is. Do we remember some words more than others because they have greater personal meaning for us? Or do we remember them because they are more unusual? Once you have thought about this issue you may read on...

We often remember what happens at the beginning of a book, film, television programme or talk. These things tend to have prominence for us. What happens in the middle, however, tends to be more of a blur. Recent facts and events are also prominent in our minds. Could anyone forget the date 9/11? Things are also prominent when they are repeated, and repeated, and repeated, and repeated, and repeated, and repeated, and repeated, and repeated, and repeated, and repeated and repeated.

If something is **PROMINENT**, for whatever reason, it will tend to be remembered.

The same is true of things that have a pattern.

$$
$$
$$
$$
$$
$$
$$
$$

Texts of various kinds can be given prominence by all of these things. The problem with trying to create textual prominence though – and giving prominence to something is really a way of highlighting certain meanings and indicating that they are more important than others – is that it often has to be done against something that is not prominent. That is why things that are exciting – whether they are objects, images or texts – may only exist when there is a contrast with things that are not exciting.

Remember that what happens at the end of a book, film, television programme or talk will also tend to be more prominent in your mind than what happens in the middle of it.

HOW LIKE REAL SPEECH IS THIS DIALOGUE?

A Play on Words

————————— • —————————

ACT ONE
Scene. A Library in Elea.

HARE. I was in a book once.
TORTOISE. Er, so was I.
HARE. (*ironically*). REALLY?
TORTOISE. Yes, really. And you don't have to shout. This is a library. Everyone is listening.
HARE. (*sotto voce*). Sorry.
TORTOISE. Anyway, I am concerned to know the designation of the book?
HARE. What?
TORTOISE. The name of the book?
HARE. *Book?*
TORTOISE. Yes, the name of the book?
HARE. *Book?*
TORTOISE. You are repeating yourself.
HARE. Pardon.
TORTOISE. You are repeating yourself.
HARE. (*slowly*). The name of the book was *Book?* You are not very quick on the uptake, are you?
TORTOISE. I am certain that it can't compare with *The Name of the Book.*
HARE. Why is that?
TORTOISE. I was the author of the book of which I have just spoken.
HARE. (*puzzled*). Blimey! *The Name of the Book?* I don't think I ever read that one.
TORTOISE. That's because it doesn't exist! So you can't really read it…except, of course, if you inhabit my imagination.
HARE. What is the point of a book that you can't read?
TORTOISE. I am not sure, but it does save you having to carry it around. Books are heavy.
HARE. As a matter of fact, I prefer light reading too.
TORTOISE. The library actually has a light reading section. Let me show you.
HARE. Did you ever see *The Name of the Rose?*

The TORTOISE *and the* HARE *gradually disappear into the dark labyrinths of the library.*

HOW LIKE REAL SPEECH IS THIS DIALOGUE?

Textual meaning is read and understood in various ways depending on how it looks (its graphological features), how it sounds (its phonological features) and what it means (its semantic features). Some examples from the previous page are given in square brackets:

Personal pronouns. Texts may be in the first-person or the third-person. Using 'I' is helpful if you want to create a personal feeling to the text. This also helps to individualize the speaker. Using 'we', on the other hand, has connotations of group definition and territoriality. ['I was in a book once.']

Prosodic features. These are aspects of stress and intonation. They can be represented by typographical features such as different typefaces (e.g., size and shape), simulated handwriting (e.g., via different stylistic features) and by aspects of punctuation (e.g., italics and exclamation marks). [REALLY?]

Fluency and non-fluency features. Fluency concerns the extent to which the language flows; non-fluency concerns the extent to which it does not flow, but stutters and hesitates...['So you can't really read it...except, of course, if you inhabit my imagination.']

Accent. Accent is often obvious in spoken language, although it may be suggested in written language by an alteration in standard spelling. ['Blimey!']

Vocabulary. Vocabulary, whether from everyday conversations or regional accents, can show the age, gender, social class and ethnicity of the persons involved. ['Anyway, I am concerned to know the designation of the book?']

Repetition. Repetition is often used to emphasize points in stories (particularly those for children), advertisements and political speeches. [HARE. *Book?* TORTOISE. Yes, the name of the book? HARE. *Book?*]

Grammar. Grammar, which concerns the way in which the sentences are constructed, may also be indicative of age, gender, social class and ethnicity of the persons involved. ['I was the author of the book of which I have just spoken.']

Interactive markers. Overlaps, interruptions, reinforcements that indicate understanding (or a lack of it), noises such as 'er', 'mm', 'um', 'oh', 'yeah', 'ugh', 'eek' and 'aargh', and monitoring expressions (phrases such as 'you know') are all interactive markers. ['Er, so was I?']

Topic changes. Topic changes are often evident in both written and spoken language. ['TORTOISE. The library actually has a light reading section. Let me show you. HARE. Did you ever see *The Name of the Rose*?']

COULD THIS BE TRUE?

The real title of the book you are reading is:

The real title of the book you are reading is:

The Postmodernist
Always Reads Twice

COULD THIS BE TRUE?

The Postman Always Rings Twice is a film that was first made in 1946. I have used the title *The Postmodernist Always Reads Twice* because postmodernism is partly about how works cannot be understood in isolation from one another, but only with reference to one another.

'Intertextuality' is the word that is used to describe how works of various kinds (e.g., books, paintings, sculptures, designs, adverts etc.) make reference – often in clever ways – to other works (i.e., other books, paintings, sculptures, designs, adverts etc.). It also describes how the various meanings that these works create are interrelated. This can happen through translation, parody, pastiche, plagiarism, allusion, homage, echo, quotation, recycling, spoof, sequel, prequel and remake. The references that works make to one another are often exemplified in terms of structure (e.g., the layout of one book might be copied from another book) or in terms of content (e.g., the plot, or else the names of the characters, might be the same).

'Intratextuality', on the other hand, is used to describe the internal relationship between different parts of the same work. This can involve such things as the relationship between two chapters in the same book, between two people depicted in the same painting, or between two or more objects that form the same collection.

When it comes to the supposedly 'imaginary' title of this book, knowing about the existence of this film enables you to understand the reference that is being made. And once you know where this 'imaginary' title originates from, and why postmodernism is about how we understand the world through multiple references, you start to realize that there is not one way of reading and understanding such an 'imaginary' title. In this way, you may come to appreciate the self-referential joke that I have tried to make. Or is it a joke?

What is a Paratext?*

What is a Paralanguage?*

What is a Paratext?*

What is a Paralanguage?*

*Please ignore these questions**

Titles, dedications, acknowledgments, blurbs, epigraphs, prefaces, introductions, footnotes, illustrations, marginalia, erratum slips, endnotes and indexes all count as paratexts. Paratexts stand outside the main body of a work and comment on it, or alter the meaning of it, in some way. The power of paratexts to change the meanings of texts can be seen if we consider the erratum slip. Suppose you are consulting a book on mushrooms. You are hoping to discover which mushrooms are good to eat from your local woods. However, an erratum slip falls from the book that says, 'Page one, paragraph two, line three, should read: "The False Morel mushroom is deadly.".' This erratum slip does more than correct an error. It undermines the whole book because if the author or publisher cannot get the facts right on the first page we may wish to conclude that the pages that follow will also be strewn with errors.

The paralanguage is about the non-verbal aspects of communication that work alongside, surround or support a given text. These non-verbal aspects of communication may serve to support or modify the meaning of the main text. For instance, when we encounter a person speaking or reading from a book we have to attend to what he says, but also to his bodily position and posture, facial expressions, the gestures that he makes, the physical proximity that he has to ourselves, the clothing he wears and whether he has established eye contact with us. In addition, we might note his tone of voice and any speaker effects that are in evidence, such as whether the piece of communication is accompanied by laughter or sadness. In other words, while we may identify a particular text as the central locus of meaning, there are things that stand outside any given text that can influence, and change, the way that we understand and interpret it.

**Please do not obey the previous instruction*

MATTERS OF INTERPRETATION

How would you interpret the following message: 10–2–4? As it stands, the message is almost impossible to understand. That is because we have no idea about how, where, why, or for what purpose it was made. Once you know its context, though, the meaning of the message is clear. This is the information you need to interpret the 10–2–4 message correctly.

The numbers 10–2–4 first appeared on the bottles and advertising of the Dr Pepper drink. The numbers were based on a piece of research on human fatigue that was conducted in 1927 which suggested that people's energy levels tended to drop to their lowest point at 10.30am, 2.30pm, and 4.30pm. As the Dr Pepper drink is supposed to give you energy, this piece of research was meant to provide a reason for consuming the drink three times a day – which some people did. The company that made the drink encouraged people to work to discover the correct interpretation of the message for themselves in the hope that this effort would make the message more palatable.

It is only when a message is difficult to interpret that we start to look beneath the surface for the deep structures, unconscious foundations, hidden symbols or underlying patterns supporting it. If a message seems transparent then we tend not to look for these things. Part of the job of a semiotician, then, is to reveal those factors which sustain and provide the background for the various forms of communication that we often take for granted. In fact, it is surprising just how much background information is necessary for us to understand the most ordinary of messages, even those that appear on the surface to be wholly transparent.

As we shall see, when it comes to the interpretation of signs our understanding is mediated through the various concepts and conceptions we have of different kinds of

MATTERS OF INTERPRETATION

subject matter; by the various connotations and denotations that objects, images and texts can have; via the arrangements and laws for constructing cultural phenomena (*langue*) as well as the particular instances that are constructed by those arrangements and laws (*parole*); by the codes we have for combining different things to create an ordered sequence of signs (syntagm) and for making appropriate substitutions in that sequence (paradigm); through the distinction between individual tokens, and generic types, of thing; by the rules that we follow for using objects, images and texts successfully; via classifications that allow us to categorize and organize things; through the conventions that draw on common forms of knowledge; and by the ways that we have devised for understanding (and misunderstanding) that which we think we know.

CAN YOU TELL THE DIFFERENCE BETWEEN OAK TREES AND ELM TREES?

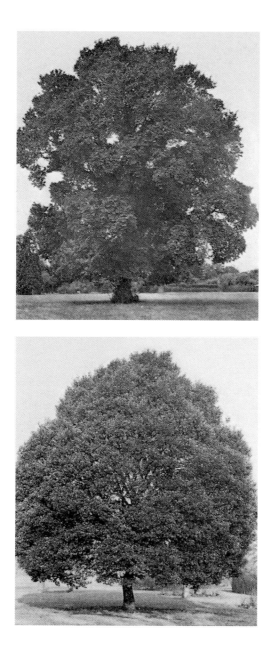

CAN YOU TELL THE DIFFERENCE BETWEEN OAK TREES AND ELM TREES?

Different kinds of information, as well as different amounts of information, can inform our concepts. Take the concepts 'oak' and 'elm'. Suppose we are talking to a neighbour about the trees in our garden. We mention that we have had our oaks and elms pruned during the year. Perhaps the neighbour understands what is being said even though they cannot, with any degree of certainty, identify which tree is which. In this case, the information that our neighbour has coded into the concepts 'oak' and 'elm' just happen to be of a rather general tree-like kind.

Now imagine that there is a second neighbour who is good at distinguishing oaks from elms. This neighbour can tell the difference between the two kinds of tree by how the trunks look, by the characteristics of the leaves and by the size and shape of each canopy. This neighbour has an understanding of oaks and elms that includes a sound recognitional ability, and so although they are using the same concepts as the first neighbour, their conception of (or thoughts about) the concepts 'oak' and 'elm' are rather more sophisticated.

Suppose that there is also a third neighbour. This neighbour is an expert in biology. He knows how to recognize the trees in question, but he also knows that oak trees belong to the genus Quercus and the family Fagaceae and that elm trees belong to the genus Ulmus and the family Ulmaceae. As he has a scientific knowledge of oaks and elms his understanding is even more sophisticated than those of the previous neighbours. (Notice, though, that someone may have a general grasp of what oaks and elms are and be able to give a biological description of them, without necessarily having an ability to recognize them. For instance, a person who lives in a country where oaks and elms do not grow may not be able to recognize them.)

If people can have different information coded into the concepts that they use, then their conceptions (or thoughts) about those concepts will tend to differ. That is why ordinary folk, gardeners and biologists may have quite different thoughts about, and interpretations of, oaks and elms even though they may talk to each other using the very same concepts.

IS THIS EXCLAMATION AMBIGUOUS?

'What nice handwriting!'

'What nice handwriting!'

IS THIS EXCLAMATION AMBIGUOUS?

When we speak it is important for the purposes of interpretation to know not just *what* is said (denotation) but *how* it is said (connotation). Suppose I am asked what I think about a particular text and I reply, 'What nice handwriting!' This comment has a single denotation. It denotes the quality of the handwriting. Yet it may have a literal connotation (i.e., the person does really have nice handwriting) or a non-literal connotation (i.e., that nice handwriting is about the only thing they have). Put another way, the connotation of the words 'What nice handwriting!' depends very specifically on the context in question and the way in which the words are uttered.

To understand connotation and denotation in images, consider how two photographs might be taken of the same person at the same time from the same position. Suppose that the first photograph taken is in colour with a soft focus and gentle contrasts. Now imagine that the second photograph taken is in black-and-white with a clear focus and strong contrasts. Each of the two photographs has the same denotation (i.e., the same things are represented), but is different in terms of connotation (i.e., they don't have the same meaning). This is because denotation is concerned with *what* is photographed, while connotation is concerned with *how* it is photographed.

The distinction between connotation and denotation applies equally to objects. Take clothes. When we wear clothes it is important not just *what* we wear (denotation) but *how* we wear them (connotation). You can wear exactly the same clothes on two occasions (denotation) but they can mean something different if the occasions on which, and the purposes for which, they are worn are dissimilar (connotation). For instance, there is a considerable difference between wearing a police uniform as a genuine police officer and wearing it as fancy dress to a party. In the first instance, the police uniform may be worn in an uptight, formal fashion to establish authority. In the second instance, it may be worn in a relaxed informal fashion to create amusement.

WHAT IS WRONG WITH THIS MENU?

MENU

Coffee and Mints

Dark Chocolate Truffle Pudding

Vegetable Pie served with New Potatoes

Pear and Stilton Tart and Toasted Walnut Salad

MENU

Coffee and Mints

Dark Chocolate Truffle Pudding

Vegetable Pie served with New Potatoes

Pear and Stilton Tart and Toasted Walnut Salad

WHAT IS WRONG WITH THIS MENU?

'*Langue*' and '*parole*' are technical terms in semiotics. '*Langue*' denotes the code (or structure, system, plan, construction or set of rules) for the object, image or text that is being used, whereas '*parole*' is about the particular instance of use that has been produced. *Langue*, then, provides the organizational means for each individual example of *parole*. Here are some examples:

Langue	*Parole*
The arrangement of menus	A particular menu
The format of a postcard	An individual postcard
The structure of a novel	A particular novel
The construction of e-mail	An individual e-mail
The design of gift catalogues	A particular gift catalogue
The organization of TV schedules	A specific TV schedule
The layout of tickets	A given aeroplane ticket
The composition of paintings	An individual painting
The regulations for wills	A particular will
The rules of grammar	A given sentence
The conventions of spoken utterances	A spoken utterance
The form of a conversation	A certain conversation
The language of film	A particular film

As we can see, each code, structure, system, plan, construction or set of rules (*langue*) does something to regulate, and give meaning to, its use in a particular instance (*parole*).

For example, an individual menu (*parole*) will conform to the general arrangement that menus tend to have in terms of layout and structure (*langue*). In order for a menu to function there will need to be a choice from a selection of interchangeable parts (e.g., from different kinds of starters, main courses and desserts), which may then be combined to reflect such things as taste, fashion, practicality and fit with certain social occasions and norms. (Think here of the design of a menu for a formal dinner as opposed to a birthday party.)

Menus, we might say, have a grammar that reflects the practices of eating. But notice that the standard arrangement of a menu may need to be changed in certain circumstances. Such a change would be required if you tried to live your life backwards. In such a case you might want a menu like the one on the previous page.

IS IT ODD TO COMBINE CLOTHES IN THIS WAY?

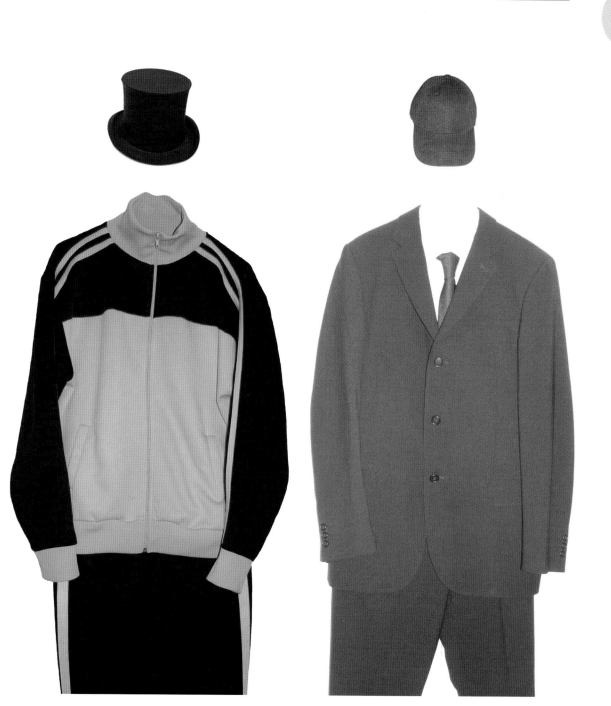

IS IT ODD TO COMBINE CLOTHES IN THIS WAY?

In the images on the previous page there is a mismatch between the clothes and the hats. Social rules dictate that the top hat should be combined with the suit and the baseball cap should be combined with the tracksuit. This is not to say that you cannot combine clothes in the way shown, it is just that doing so will tend to create a comic effect, which is fine if this is the effect that the wearer wants to achieve.

Different societies use different cultural codes to regulate how clothes are combined. These codes may reflect pre-existing canons of taste (e.g., 'Ought I to wear red trousers with green shoes?'), social demands (e.g., 'Which group will I identify myself with by wearing a bandana?') or ritual episodes (e.g., 'How should I dress if I am going to a job interview as opposed to a sports event?').

When we put clothes together to form an ensemble we call this a 'syntagm'. A syntagm is any combination of things that conform to a specified set of social rules.

That is why, when we notice the inappropriateness of the combination of clothes that a friend has assembled for the purpose of going to a funeral, we may say: 'Your sombre shirt goes with this dark pair of trousers, but not with this jolly pair of yellow socks, which will undermine the serious mood of the event.'

In addition to the rules of combination that form a syntagm, there are rules of substitution that form what is called a 'paradigm'. A paradigm is created by the social rules that dictate when one thing can be substituted, added or removed in a certain system without that system being undermined overall. Take clothes as our example once again. If we wish to dress casually then we can substitute different kinds of T-shirt with the one we are wearing without it necessarily affecting the overall casual clothing 'syntagm' that we are trying to create. What we cannot do is substitute a formal dress-shirt for this T-shirt, as this will undermine the casual effect that is intended.

HOW MANY WORDS ARE THERE IN THIS BOX?

MANYMANYMANYMANYMANYMANY
MANYMANYMANYMANYMANYMANY
MANYMANYMANYMANYMANYMANY
MANYMANYMANYMANYMANYMANY
MANYMANYMANYMANYMANYMANY
MANYMANYMANYMANYMANYMANY
MANYMANYMANYMANYMANYMANY
MANYMANYMANYMANYMANYMANY
MANYMANYMANYMANYMANYMANY
MANYMANYMANYMANYMANYMANY
MANYMANYMANYMANYMANYMANY
MANYMANYMANYMANYMANYMANY

HOW MANY WORDS ARE THERE IN THIS BOX?

```
ONE  ONE  ONE  ONE  ONE  ONE
ONE  ONE  ONE  ONE  ONE  ONE
ONE  ONE  ONE  ONE  ONE  ONE
ONE  ONE  ONE  ONE  ONE  ONE
ONE  ONE  ONE  ONE  ONE  ONE
ONE  ONE  ONE  ONE  ONE  ONE
ONE  ONE  ONE  ONE  ONE  ONE
ONE  ONE  ONE  ONE  ONE  ONE
ONE  ONE  ONE  ONE  ONE  ONE
ONE  ONE  ONE  ONE  ONE  ONE
ONE  ONE  ONE  ONE  ONE  ONE
ONE  ONE  ONE  ONE  ONE  ONE
```

How you interpret these questions depends on whether you think of the words as tokens or types. The number of tokens is the same as the number of words in the box. In the first box there are 72 tokens of the word 'many'. In the second box there are 72 tokens of the word 'one'. But in each box there is only one word of the same type. In the first box, 'many' is the type of word that is being used. And in the second box 'one' is the type of word that is being used. Notice here that different tokens of the same type of word may be interpreted in different ways according to how they are produced. Here are three tokens of the same type of word, each with a different emphasis: smell, Smell, SMELL. In this instance, each token may be interpreted in a different way because of the variation in emphasis that it has been given.

The token and type distinction can be applied to objects and images just as much as to texts. A particular bronze sculpture can exist as a token object in a specific museum. But if we know that more than one bronze sculpture has been cast from the original mould then we might expect to encounter bronze sculptures of exactly the same type in other places. Similarly, a print (e.g., an etching) can exist as a series of tokens if there is a printed edition of it. Each token print (given that it is printed from the same plate) is an example of the same type. The same distinction between tokens and types holds for replicas (e.g., decorative mouldings), duplicates (e.g., wills), facsimiles (e.g., manuscripts), carbon copies (e.g., letters), reproductions (e.g., furniture), reprintings (e.g., books) and models (e.g., cars).

Somewhat surprisingly, what holds for objects, images and texts holds also for thoughts. If two people say the words 'I like semiotics', they will each be uttering a different individual token of the sentence, but they will be having a thought of the same type.

WHAT ARE THE RULES FOR USING THIS CORKSCREW?

WHAT ARE THE RULES FOR USING THIS CORKSCREW?

When faced with everyday objects we follow the rules that we think will allow us to use them successfully. The rules for using a corkscrew are simple enough. They are:

1. Grasp the handle of the corkscrew firmly and insert the screw thread into the bottle by twisting it in a clockwise direction.
2. Once the thread has been fully inserted into the cork, draw slowly on the handle of the corkscrew while maintaining a tight grip on the bottle with your other hand until the cork is released.

These rules are fine for a right-handed person using a right-handed corkscrew. However, they are wrong, or at least misleading, for a right-handed person who is attempting to use a left-handed corkscrew. This is because the thread on a left-handed corkscrew (like the one shown on the previous page) goes in the opposite direction. To use a left-handed corkscrew successfully you need to turn it in an anti-clockwise direction.

What we should learn from the example of the left-handed corkscrew is just how much we rely on interpreting certain rules correctly, and just how much our success in doing so depends on hidden assumptions, social customs, cultural norms, kinds of conformity, forms of training, traditions of use and educated propensities. The rules that we use are important to reflect upon directly because we often fail to see just how much our behaviour and our actions depend upon them. Indeed, every day we are faced with objects that have tacit instructions for their use, images that have masked codes for their interpretation and texts that obey the, often hidden, regulations that are set by the institution of language. In failing to notice these rules we also fail to see the opportunities for questioning them and thereby creating new codes and forms of meaning.

DOES THE WOMAN IN THE CENTRE OF THIS PICTURE LOOK REAL?

DOES THE WOMAN IN THE CENTRE OF THIS PICTURE LOOK REAL?

In Sandro Botticelli's *Birth of Venus* (*c.* 1485–86) we see a woman about to step on to the seashore from a giant shell. There is something odd about this figure. The elongation of her neck, the curious sloping of her shoulders, the awkwardness of her arms and legs and the sheer length of her body all go to make her seem unnatural in some way. There is actually an obvious explanation for these anatomical peculiarities: this is not a real woman. It is the goddess of love and beauty, Venus. So what is being represented is an ideal of beauty. That is why Botticelli uses elongation and distortion in the picture. The only difficulty is that to interpret this message you have to understand the conventions that are being used. Conventions are agreed systems of understanding that allow us to interpret what is happening. In this instance, you need to understand that by elongating the human body – a convention still to be found in contemporary fashion drawing – Botticelli idealizes the female form in order to make it more beautiful.

Conventions are often so much part of a culture that we fail to realize that the codes they use are not always transparent to cultures other than our own. Just how much we assume about the transparency of certain common codes can be seen from a plaque that was put on the *Pioneer* F spacecraft, a probe that was sent into space in the 1970s. The plaque had a line drawing of two human beings, a man and a woman. Its purpose was to communicate the presence of human life on earth in such a simple way that any intelligent form of life that might happen to come across it in space would be able to interpret it immediately. However, in order to read the intended message any alien form of life would have to understand that the lines stand for contours, that the figures are in perspective and that the right hand of the man (which is raised) is supposed to signify a greeting. Yet even supposing that the intended audience of aliens had eyes, which in itself is a big assumption, it is still quite unclear that the message could be understood without the requisite knowledge of the conventions of pictorial representation that have, unwittingly, been supposed to be wholly transparent by those who made the drawing.

IS THIS ART?

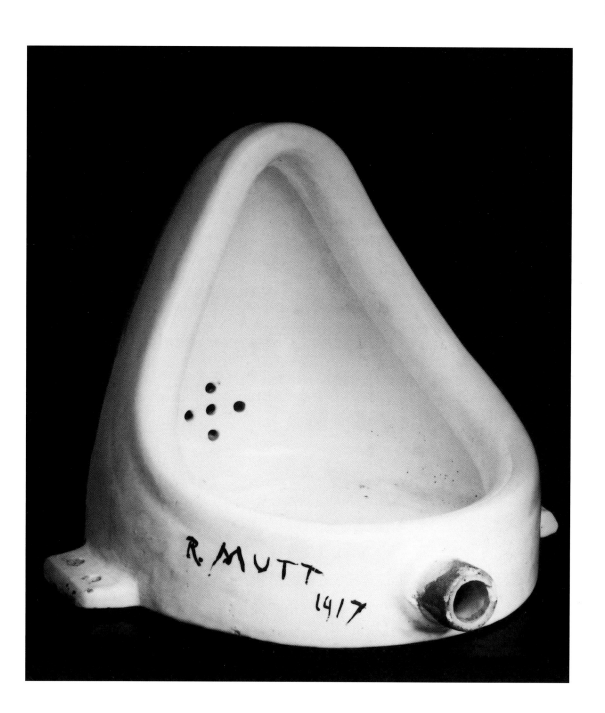

IS THIS ART?

The way we classify things is important. The botanical sciences would never have made progress had it not been for the orderly cataloguing of flora. Libraries and museums would not have grown without the highly-developed systems that were devised for organizing and arranging their collections. And governments of all periods would not have been able to function without some way of categorizing and grading information into that which is, and that which is not, confidential.

The need for classification is clearly evident from many human fields. Progress itself seems to depend on it. However, while certain things seem to be amenable to classification, others do not. For instance, what sorts of things should we classify as art? Here are some possible responses:

1. All the things that people are generally disposed to call 'art'.
2. All the things that connoisseurs of art call 'art'.
3. All the things that I call 'art'.
4. All the things that are displayed in art galleries with the purpose of being viewed as art.

5. All the things that are called 'art' by artists.
6. All the things that common sense tells us are art.
7. All the things that have the intrinsic properties of art.
8. All the things that cause an artistic reaction in the viewer.

Each of these responses provides a very different answer, and hence a very different principle of classification. There is, respectively, a concern with (1) The Public, (2) The Expert, (3) The Self, (4) The Institution of the Museum or Gallery, (5) The Artist, (6) The Discriminations of Common Sense, (7) The Qualities of the Object, (8) Our Aesthetic Response to Objects.

When it comes to Marcel Duchamp's famous *Fountain* (1917) (or urinal) we find that there is no definitive answer as to whether or not it is art. For there is no independent fact to which we can appeal to decide the matter once and for all. In a way, then, the point of Duchamp's piece may be to raise the question about the scope and limits of art rather than to give an answer as to what art is.

WHAT DOES THIS GESTURE SIGNIFY?

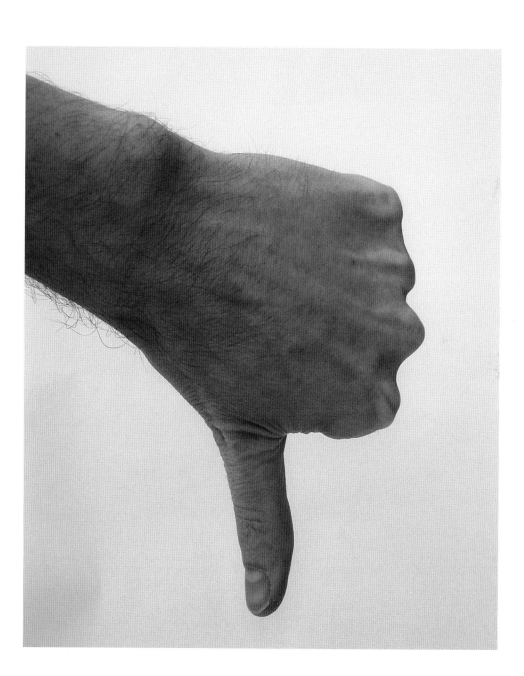

WHAT DOES THIS GESTURE SIGNIFY?

Gestures are rich in meaning. As a condensed non-verbal source of communication they appear to be a trouble-free way to express approval or disapproval, affection or disaffection and assent or dissent.

Some gestures, such as pointing, have meanings that appear to be more or less universal. Others, however, such as the thumbs-up sign, and its cousin the thumbs-down sign, seem to have different meanings in different contexts. For instance, the thumbs-up sign, when used in the West by pilots before take-off, by hitch-hikers wanting a ride or by divers checking their underwater equipment, is interpreted in an affirmative fashion. However, the very same gesture in the Middle East is viewed in the opposite way. If it is made in that context then it can be insulting. So even a simple gesture such as this can produce grave misunderstandings when interpreted in the wrong way.

The history of the thumbs-down sign is an intriguing one. This sign, which was popular in many Hollywood epics that involved gladiatorial combat, was thought to have been used by the ancient Romans to signal death. However, it seems that Hollywood actually promoted a misinterpretation of the sign. This misinterpretation arose because Hollywood followed the example set by Jean-Léon Gérôme, a French academic painter, in a picture called *Pollice Verso*, which was painted in 1872. Unfortunately, when researching his picture, Gérôme mistranslated the Latin word for 'turned in' to 'turned down', and so, rather than using the correct Roman sign for death (i.e., the turned-in thumb accompanied by a stabbing motion towards the chest), he employed the thumbs-down sign. It is curious that this misunderstanding has now become so entrenched that the original – and correct – meaning of the thumbs-down sign has almost been lost.

CHAPTER SEVEN

FRAMING MEANING

Starting with different units of meaning, the aim of this chapter will be to build a framework that will allow us to understand communication in terms of the wider context of society and culture. The notions we will examine are as follows:

Semantic Unit = The thing that expresses meaning
Genre = The category of expression
Style = The manner of expression
Stereotype = The clichés or norms of expression
Institution = The place or site of expression
Ideology = The ideas and values that are employed to justify, support or guide expression
Discourse = The uses of expression that create or reflect different aspects of the social order
Myth = The stories that represent and shape individual or collective expression

Paradigm = The theories that configure expression

In order to understand how objects, images and texts fit with the groupings we have just defined I have given some examples of their application below:

Chair (Semantic Unit)
Office furniture (Genre)
Functional (Style)
An object with a rather nondescript look (Stereotype)
Shop (Institution)
Consumerism (Ideology)
Need (Discourse)
Practicality (Myth)
Modernism (Paradigm)

We can explain this example quite simply. A chair (Semantic Unit) might be a piece of office furniture (Genre) that is practical, with an appearance that is

FRAMING MEANING

functional (Style). Thanks to the exclusive emphasis on function, this type of furniture may be rather bland (Stereotype). Purchased from a shop (Institution), this piece of furniture might be viewed in the wider context of consumer society, *viz* one where the value of buying and selling goods seems obvious to everyone (Ideology). In terms of justifying this purchase we might talk about the need to avoid backache (Discourse) because of the long periods sat at our office desk. Here the language of practicality (Myth) might also be invoked. And finally, our understanding of the piece of furniture in question may be framed by the epoch that contributed most to functionality and practicality in design, Modernism (Paradigm).

The concepts we have articulated apply equally to images and texts. Here are two more examples:

Painting (Semantic Unit)
Portraiture (Genre)
Academic (Style)
A lifelike depiction of a sitter (Stereotype)
Gallery (Institution)
Naturalism (Ideology)
Objectivity (Discourse)
Genius (Myth)
Realism (Paradigm)

A painting (Semantic Unit) might be a portrait (Genre), executed in an academic manner (Style), with a corresponding attempt to be lifelike in its execution (Stereotype). Exhibited in a gallery (Institution), the picture might present itself as a naturalistic and detached view of the sitter (Ideology). The description that accompanies the picture might speak of the objectivity of vision (Discourse), the rare talent and skill of the artist who carried it out (Myth), along with the tradition of realism in which it should be viewed (Paradigm).

Book (Semantic Unit)
Children's story (Genre)
Informal (Style)
The fairy tale (Stereotype)
Library (Institution)
Educational (Ideology)
Learning (Discourse)
Innocence (Myth)
Victorianism (Paradigm)

A book (Semantic Unit) might be a children's story (Genre), written in an informal fashion (Style). It could be a familiar fairytale (Stereotype), and it might be borrowed from a library (Institution). The jacket of the book could highlight the educational opportunities that the reading of the book affords (Ideology) and in so doing describe the moral lessons that may be learnt from it (Discourse). The parent reading the jacket of the book may interpret its content in terms of childhood innocence (Myth), and by way of certain received Victorian ideals concerning the purity of youth (Paradigm).

HOW SHOULD WE JUDGE THIS IMAGE?

HOW SHOULD WE JUDGE THIS IMAGE?

Semantic units are discrete items of communication that have actual and potential meanings. A semantic unit is an aspect or part of a thing, a thing itself or a collection of things that can be identified as distinct elements of communication.

Text-based semantic units are the easiest to identify: they consist of words, sentences, paragraphs, pages, chapters or books. We know this because when we are unable to understand a particular textual element we can ask: 'What does this particular word/sentence/paragraph/page/chapter/book mean?'

With images, the issue is more difficult. A painting can have brush-marks, lines, tones, textures, colours and different parts, all of which can be identified as meaningful – of course the picture as a whole has a meaning too. Once again, we can identify the semantic unit in question by picking out that which is not understood by asking: 'What does this particular mark/line/tone/texture/colour/part of the image/whole image mean?'

Parts of objects, objects themselves and collections of objects can be thought of as semantic units too. In this instance, when we are mystified we might ask: 'What does this part of the object, this whole object or this collection of objects mean?'.

One problem with semantic units is in knowing exactly where one begins and the other ends. This might happen, for example, in a case where there seem to be two individual photographs that completely overlap (as on the previous page). Here we have two choices. Either we can treat the image as a mistake and try to read each of the semantic units of which it is composed separately, or we can treat the image as a whole semantic unit and assign it a single set of meanings. Which option we choose in this case may depend on what we think was the intention of the photographer.

For the purposes of this chapter we will look at semantic units as complete things (e.g., books, paintings, chairs), while tending to ignore the problem of parts, collections and the issues of overlap.

IS THIS A LANDSCAPE OR A PORTRAIT?

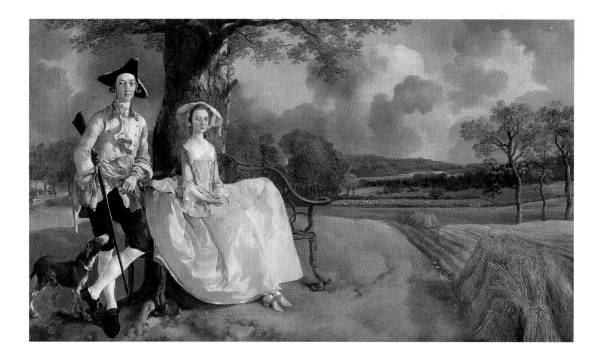

IS THIS A LANDSCAPE OR A PORTRAIT?

Genres are categories that conform to a certain division or sub-division of a particular medium. Design has the genres of graphics, multi-media, furniture, product, industrial, domestic ware, textiles and fashion. Magazines have the genres of advice, entertainment, information and instruction. Television has genres of news, soap opera, education and comedy. Books have the genres of the novel, the diary, biography, history and poetry.

The genres just listed can obviously be further divided – though whether we want to say that the divisions are themselves genuine genres is open to debate. Furniture design can be for the home, work or leisure. Magazines can offer advice that is serious or light. Television news can be factual or anecdotal. Poetry books may be confessional or descriptive.

Each semantic unit, whether object-, image- or text-based, will often be communicated through a well-established genre. The genre chosen will tend to set up a series of codes that allow the communicative act to take place successfully. These communicative acts will often only be truly productive when they conform to the rules of the genre in question (i.e., when there is some shared understanding of what the genre requires). One of the rules of film is that there cannot be a change of genre halfway through. For example, a science fiction film should not suddenly change in the middle to a western. Making this switch is forbidden because it would confuse the audience. The same is true of a news report that starts with some serious event and ends with a piece of gossip.

The painting by Thomas Gainsborough of *Mr and Mrs Andrews* (c. 1750) on the previous page presents us with an apparent exception to this rule in that it appears to combine portrait and landscape. So why is this allowed? The obvious answer is that the picture depicts a moment where two genres coalesce. In this sense it is rather like the way in which some films combine the genres of romance and comedy. What this shows is that a single semantic unit can contain melded genres but not genres that are sequential.

WHAT KIND OF PERSON HAS WRITTEN THIS SENTENCE?

I am not a criminal.

I am not a criminal.

WHAT KIND OF PERSON HAS WRITTEN THIS SENTENCE?

A style is a manner of doing something. The style in which something is done can influence how a message is received. This is true of the sentence on the previous page. The elegant type-face in which the sentence 'I am not a criminal' is written seems to make it more believable.

When it comes to message-making we should not forget that the form of the message matters as much as the content. To demonstrate this point, compare the following examples:

PLEASE TRUST ME.

Please trust me.

Please trust me.

Please trust me.

PLEASE TRUST ME.

Please trust me.

Please trust me.

Please trust me.

PLEASE TRUST ME.

PLEASE TRUST ME.

Please trust me.

Please trust me.

Please trust me.

Please trust me.

Please trust me.

Please trust me.

What is remarkable here is just how much the style of type-face can influence how we feel about the sentence.

Different styles can be exemplified in writing, painting, designing, dressing, acting, walking, talking and even thinking. If we undertake any of these activities then we will be sure to do so in a way that is distinctive and personal. It is always within our power to develop our own particular and individual style of writing, painting, designing, dressing, acting, walking, talking or thinking. At the same time, however, our own way of doing these things will tend to make reference to a more general way of doing them. In other words, while there are individual styles, these usually partake of styles that are social and cultural in origin. Thus, the way in which we talk will not be independent of a community of people who talk in a similar way, for example in terms of accent. The accent that you have will always be a cultural and stylistic variation of a particular language.

WHAT MAKES THIS WORK OF ART NON-STEREOTYPICAL?

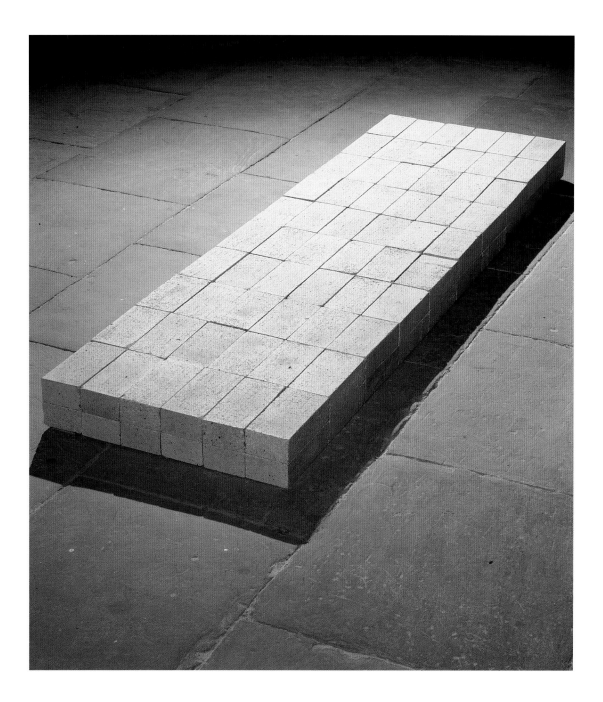

WHAT MAKES THIS WORK OF ART NON-STEREOTYPICAL?

A stereotype is a generalized idea of something. There can be stereotypes of different kinds of objects, images, texts, animals, plants, people or groups of people. These stereotypes often derive from certain observations, thoughts or prejudices that may or may not be grounded in fact. For example, the stereotype of a woman car driver is of someone who lacks certain competences in driving. Yet the stereotype is not accurate. If it were accurate then insurance companies would be right to charge women more to insure their cars than men. What we find, however, is that men are charged more because in reality they tend to be less competent drivers than women.

Stereotypes are sometimes helpful to us. They can give us a short-cut to understanding a certain thing or situation. At the same time, however, they tend to be rather inflexible and simplistic. We might think, for example, of an artwork in terms of certain stereotypical materials. Sculptures, for instance, tend traditionally to be made from stone, bronze or wood. Sculptors of the twentieth century, though, broke away from these stereotypical materials and used such things as glass, plastic, concrete and even waste.

Carl André's *Equivalent VIII* is an example of what is called Minimalist sculpture. It consists of two piles of ordinary bricks laid out in an oblong. One might say that it provides a challenge to the stereotype of what sculpture is, but also to our notion of how art is valued (not least because the Tate Gallery in London paid $12,000 to buy it in 1972). Another answer as to what makes it non-stereotypical is that it is made from everyday materials. (Though in recording these answers we might also wonder whether the assumption that the question makes, namely that this is a genuine work of art, is right in the first place.)

HOW MIGHT THE DISPLAY OF AN OBJECT INFLUENCE HOW WE FEEL ABOUT IT?

HOW MIGHT THE DISPLAY OF AN OBJECT INFLUENCE HOW WE FEEL ABOUT IT?

As institutions, museums are characterized by the fact that they remove objects, images and texts from the typical arenas of production, consumption, ownership, use and exchange that they tend to inhabit. By making the museum into a sanctified zone for display, objects, images and texts (i.e., various semantic units) are thereby abstracted from the concreteness of the social and historical practices in which they normally participate. The objects, images and texts that are displayed in the museum are usually enhanced through the presentational codes of staging. By putting objects in glass cabinets, by raising sculptures on plinths, by putting pictures in ornate frames, by lighting books in a reverential fashion, by providing academic and quasi-academic forms of written information on invitation cards and labels, and in catalogues, leaflets, handouts and pamphlets, or by simply placing rope around an area of display in order to cordon it off, the pieces on show are set apart from the spectator. And this in turn serves to remind the museum-goer of the sense of reverence that they are expected to have towards what has been put on display.

Just like the museum, other institutions act to regulate cultural meanings and the social behaviour that goes with them. Churches regulate meanings and forms of behaviour through their holy books, by designated areas of worship and through the prescribed courses of action that go with the ceremonies that they have devised. Houses regulate meanings and behaviour by the way in which such things as walls, windows, fences, doors, locks, bars and other security devices are configured to create segregation. Courts of law regulate meanings and forms of behaviour through the layout of their rooms and corridors (thus keeping lawyers, jurors and the accused apart) and by rules of procedure (which dictate the formal modes of address that control the interactions between participants).

WHAT IS WRONG WITH THIS MAP?

WHAT IS WRONG WITH THIS MAP?

In this 'upside-down' map of the world Africa, rather than Europe, appears to be at the centre. This makes it seem wrong, though in reality it is not wrong, but merely presenting an alternative view of things, or ideology, that may actually help us to see the world in a different way.

Ideologies are about ideas: what they are and how they are formed. Ideas are not natural. On the contrary, they arise from, and can be explained in terms of, particular forms of society and culture. The key question for those interested in ideology in relation to semiotics is just how our ideas fit into larger systems and structures of meaning that particular societies and cultures create and enforce. To answer that question, though, we need first to understand the various forms that ideology might take. Ideology might be understood as either:

1. A system of beliefs and desires that are characteristic of the value system of a particular class, group or culture. Political beliefs tend to be like this. Thus right-wing ideology tends to place value on tradition, authority and hierarchy, whereas left-wing ideology tends to place value on equality, liberty and community.

2. A system of illusory beliefs or desires that can be contrasted with beliefs or desires that are true. Marxists view ideology in this way. Thus Marxists argue that by the propagation of certain ideas the working class is tricked into accepting an economic and social order where the upper class is in charge.

3. The general process through which our systems of belief and desire are produced and consumed. On this view, various parts of a society or culture act to produce (and also make available to consume) certain styles of thought or ways of thinking. For instance, popular newspapers tend to promote the ideology of the person who is of value to society just because they are rich or famous.

WHAT DOES THIS THRONE SAY ABOUT THE PERSON WHO MIGHT SIT IN IT?

WHAT DOES THIS THRONE SAY ABOUT THE PERSON WHO MIGHT SIT IN IT?

Discourse analysis tends to focus on language and the contexts of its meanings, but objects (and images) set up and sustain discourses of their own. For example, the throne of a king (like the one on the previous page) sets up its own discourse. It is a discourse that is meant to give authority and status to its user.

In general, discourses help to form our ideas about the world through regulated forms of use. Discourses consist of different areas of knowledge, norms of 'lived' experience, structures of organization, systems of regulation and kinds of identity. Discourses set the boundaries of these things through established forms that create or reflect particular aspects of society and culture. For example, there are professional discourses (evident in the expert languages of law or medicine), discourses of competition (prevalent in Western ideas of economics and political economy), discourses of solidarity (made manifest through various religions and via the idea of a nation state), discourses of learning (manufactured and sustained by established education

systems), discourses of sexism (palpable in the expressions, both verbal and visual, of individuals who think that men are superior in some way to women) and many others, all of which both shape and replicate our attitudes to different people, styles of living, institutions, objects, images and texts.

Take the discourses of cleanliness (which partake of the more general discourses that focus on health) as an example. The discourses of cleanliness, which since the Victorian period have been prevalent in Western culture, are promoted in different ways and through different media (e.g., educational leaflets, television news stories, housekeeping books, tips in glossy magazines and adverts for cleaning products). These discourses act in different ways, and through different media, to make what is known – that cleanliness is important for sustaining good health – seem to be simply a matter of common sense. Indeed, this is the aim of all dominant discourses: to make what is a cultural and societal product seem to be natural and self-evident.

DO THE LIVES OF ARTISTS INFLUENCE HOW WE SEE THEIR PICTURES?

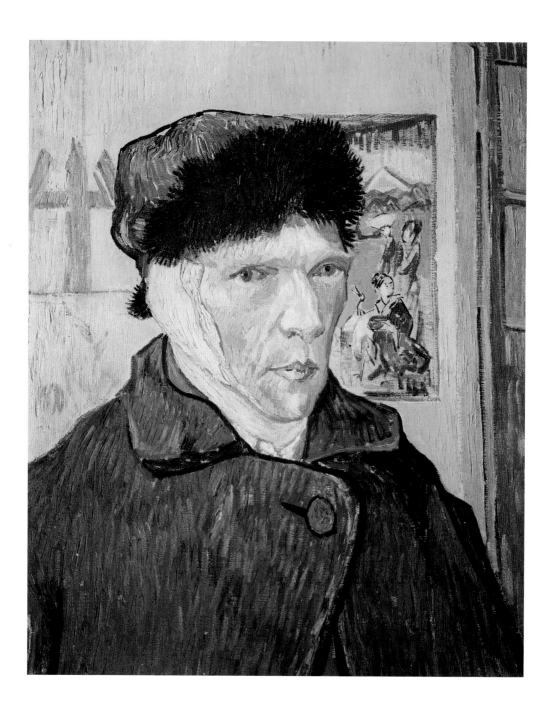

DO THE LIVES OF ARTISTS INFLUENCE HOW WE SEE THEIR PICTURES?

Myths help us to understand the world. We tend to think of myths as being ancient stories that are probably not true. But in the more general sense a myth may be considered true, partly true or else simply false. It all depends on the myth in question and the function that it serves. There are numerous kinds of myth. There are urban myths (stories that, whether true or not, are supposed to give us some moral insight), product myths (products that, whether they really do so or not, are supposed to bring us such things as health, wealth or happiness when we purchase them) and image myths (images that, whether they really do so, appear to enhance our social standing or the social standing of others). There are also more specific myths: the myth of childhood (the idea that our youth was a time of innocence, naturalness and freedom); the myth of the self (the idea that the self is a single thing that has its very own distinctive thoughts, beliefs and desires); and the myth of the countryside (the idea of a place where we can experience unadulterated nature). Other myths that dominate contemporary society include the myths of science, politics, religion, design, art and the lives of the rich and famous.

One of the most interesting myths is that of the artist. The lives of artists are often seen as dramatic. This is particularly true of Vincent Van Gogh. We think of him in poverty, we contemplate his famous fatalistic love affair, we speculate about the severing of part of his ear and we wonder over his mental turmoil and final death. All these biographical details cannot fail to influence how we view his work as they all go to form the myth of Van Gogh. However, imagine that out of the blue someone discovers that these details are untrue. Van Gogh, it turns out, lived a blissfully happy life. Would this be enough to change the myth and hence the meanings of all of his pictures? In particular, would you then view the painting on the previous page as something other than melancholic?

WHAT DO THESE DOODLES MEAN?

WHAT DO THESE DOODLES MEAN?

Sigmund Freud made these doodles. Once you know this do you see them in a more Freudian way? We know that Freud emphasized the importance of hidden desires. Therefore, maybe he was expressing his own hidden desires when he made these doodles.

In general, our readings of objects, images and texts are framed by what we call paradigms. A paradigm is a way of seeing the world though a highly structured framework of concepts, procedures and results. And so, given that Freud made these doodles, what we see in them may be structured by particular Freudian concepts (e.g., the unconscious, the psyche), procedures (e.g., the process of analysis) and results (e.g., the identification of a complex or phobia). In particular, these drawings appear to show spirals that are descending. For this reason they might represent a journey into the depths of the mind itself, or they may say something about Freud's own subconscious fear of falling into some hole or recess. Perhaps they indicate a fear that is sexual in some way.

Now suppose that these drawings were not by Freud. Instead, imagine that they were by Albert Einstein. Would that change how you read them? If you think it would, then is this because you would start to apply a different set of concepts, procedures and results to them (i.e., those that you associate with the work of Einstein)? Such a radical alteration in your perception is called a paradigm-shift. A paradigm-shift happens when an alternative way of thinking is provided by a new set of concepts, results and procedures. The change in perception takes place due to the new framework or theory that you now use to interpret your experience. A paradigm-shift in this instance would take place if you shifted your interpretation from a Freudian one to an Einsteinian one.*

*Freud did, in fact, draw these images.

STORIES AND STORYTELLING

Human beings are the only animals that tell stories. We find human stories in every geographical location, in every historical period and in every culture. Stories, then, seem to transcend international, historical and cultural boundaries.

As stories are so ubiquitous this might lead us to think that they have a function. So why do we tell stories? There are various reasons: to give instruction, to provide hope, to control behaviour, to transmit ideas in a memorable form, to enhance social cohesion and to give human beings a better way of understanding themselves and others in terms of their needs, desires, motivations and actions. All of these reasons and more can be used to explain our need to tell stories.

What forms do stories take? Novels, films, comics, cartoons and biographies are the forms that are most familiar to us. In a rather less obvious way, though, we can also say that books on history, television news, gossip columns, TV documentaries, performances of mime, stained glass windows, some paintings and most advertisements involve some form of storytelling.

So are there any areas of life or any disciplines where stories are not told? What, for instance, about science? Surely science is about facts and not about storytelling? The response here might be to say that while science does not involve storytelling directly, it often describes its progress in a form that is story-like. After all, science starts with mystery. The mystery then leads to a conflict (usually within the scientific community), which continues until there is a major turning-point (which often consists in a discovery). When this discovery can be reproduced by other scientists, both the mystery and the conflict disappear, and that tends to result in a resolution within that community. These factors – mystery, conflict, turning-point and resolution – are the same as those that we often find

STORIES AND STORYTELLING

in storytelling. So even if we wanted to conclude that science does not tell stories then we would still have to admit that it uses key features of storytelling to explain itself.

Human beings have always searched for a way to reveal who and what they are. While philosophers have sought to develop a grand scheme or theory that would serve to explain the nature of human beings and society, storytellers have found something that, although it is not a 'grand scheme' or 'theory', does, in all its diversity and multiplicity, help us to say what we are and why. Stories and storytelling have what we might call a 'totalizing force' for human beings. Stories are the master structures that guide and inform both our most light-hearted as well as our most profound beliefs, desires, thoughts and interactions. Stories expose our most intense worries and our greatest hopes; they give expression to our outward feelings and they help us to record the deepest of our inner monologues. I have tried in this last chapter, then, to discuss the concepts that are central to stories and storytelling. They are: fact and fiction, narratives, legends, characters and personas, viewpoints, mysteries, tensions, turning-points and resolutions.

DID CHRIST REALLY DIE ON THE CROSS?

DID CHRIST REALLY DIE ON THE CROSS?

There are all kinds of questions about Christ. Was he a real man? Was he the son of God? Are the stories that are told about him factual? Or are they merely fictional?

One of the most powerful images in Western art is that of Christ on the cross (represented in this instance by Masolino [1383–1447]). It is an image that has been repeated by artists over hundreds of years. Yet it is easy to forget that this symbol of crucifixion is just that: a symbol. The reason that we should regard it as symbolic, and not as historically accurate, is because it is not the same shape as the crosses that were commonly used by the Romans for the purpose of crucifixion. The Romans, instead of using the Latin – or long – cross, used a T-shaped cross. And so it is likely that if they crucified Jesus then this is the type of cross that they would have used. The symbolic nature of the cross also helps to explain why there are different symbols for Christ's death: the X-shaped cross (of St. Andrew), the Greek-shaped cross (with its arms of equal length) and the Maltese cross (with its serif-like edges).

What matters in this Biblical story is not its factual accuracy – as the early Christians did not allow images to be made to represent the crucifixion there are no good ways to check on the facts – but the moral that lies behind it. The crucifixion is one of the greatest moral stories ever told. And in reading the Bible we should remember that the emphasis is on telling stories that have a meaning for human action rather than (say) on a reporting of mere events from which lessons may be learnt. If the Bible were written like a court report then it might be appropriate to read it in that way, but because, for the most part, it is written like a story, it would be wise to read it as one.

WHAT MAKES THIS A STORY?

Boy meets Girl.
Boy loses Girl.
Boy wins Girl back.

Boy meets Girl.
Boy loses Girl.
Boy wins Girl back.

WHAT MAKES THIS A STORY?

If we were told a story about a boy who met a girl, immediately won her over and lived happily ever after, then the story would not be very interesting. It is only if a story presents a problem and a series of tasks to be overcome, that our interest in it will be sustained.

One feature of this simple story that makes it engaging is the real sense of loss that the boy feels at losing the girl. This loss can occur at different points in the story. And according to where it occurs the ending will be either happy or sad. In the traditional format of the story we have a happy ending: boy meets girl; boy loses girl (unhappy); boy wins girl back (happy). But the story can be reversed: boy meets girl; boy wins girl (happy); boy loses girl (unhappy). What is important to both stories is that there is some significant event that provides a disturbance that gives rise to a disequilibrium between the two characters. This disequilibrium is what leads to drama.

Various sorts of disturbance, both large and small, that serve to create a disequilibrium in a story can be seen in film, literature, art, design and advertising. Take advertising as an example. Creating different kinds of disturbance that lead to a feeling of disequilibrium is one of the most popular techniques used to sell products. This is because when an advert creates a feeling of 'disturbance' in a customer – and this usually manifests itself in terms of dissatisfaction – then there will be a chance to return the customer to a feeling of equilibrium once more through a purchase. So a pang of hunger will provide for the possibility of selling food. A feeling of extreme discomfort will provide for the possibility of selling painkillers. A worry about our attractiveness will provide for the possibility of selling cosmetics. A sense of inferiority will provide for the possibility of selling all manner of goods and services that will enhance our status.

CAN YOU EXPLAIN THIS STORY?

A strange thing happened to my best friend, Alex Baker. Every day Alex would catch the bus to work. Invariably, at the first stop, a blind man would get on, pay his fare and sit down next to him. One day the blind man had no money for the ride, and so, out of generosity, Alex paid for him. The blind man thanked him, but warned, 'I would strongly advise you to walk home this evening.' Alex took his advice. Later that evening, Alex turned on the television only to find that the bus he had been due to take home had been subject to a terrorist attack.

The next day the blind man was not on the bus. He never reappeared.*

A strange thing happened to my best friend, Alex Baker. Every day Alex would catch the bus to work. Invariably, at the first stop, a blind man would get on, pay his fare and sit down next to him. One day the blind man had no money for the ride, and so, out of generosity, Alex paid for him. The blind man thanked him, but warned, 'I would strongly advise you to walk home this evening.' Alex took his advice. Later that evening, Alex turned on the television only to find that the bus he had been due to take home had been subject to a terrorist attack.

The next day the blind man was not on the bus. He never reappeared.*

CAN YOU EXPLAIN THIS STORY?

Urban Legends – which are sometimes referred to, incorrectly, as 'urban myths' – are stories that are not true, but are told as if they were true. They may be recounted through jokes, wisecracks, anecdotes, sayings, proverbs, gossip, chitchat, rumours and folklore in such a way as to suggest that they happened to someone close to the teller (e.g., a relation or a friend of a friend). And this gives them a false credibility. The themes of the Urban Legend are often similar. They include taboos such as food contamination (the worm burger, the deep-fried rat, the goat curry, the mouse in the bottle), the threat from outside (alligators in the sewers, the beast of Bodmin Moor) and conspiracy theories (the USA started World War Two, Jewish people were responsible for 9/11). In terms of their content, these legends can be shocking, strange, uncanny, curious and even funny. But they exist for a purpose. Their purpose is primarily to communicate some sort of moral to others in a simple, transferable and memorable form.

Urban Legends are often interesting when linked to objects, images and texts. The speed and power of the Harley Davidson, for example, has encouraged the legend of the Hell's Angels, with all manner of stories – some of which are true – about their violence and sexual prowess. The Turin Shroud, which was said to have the image of Christ imprinted on it, has also been the subject of speculative stories concerning how it came into being. *Macbeth* by Shakespeare has been the focus of many stories of bad luck, including numerous tales of serious injuries to actors who have been asked to perform it. These are all examples of our ability to be taken in by Urban Legends.

The story about Alex Baker has been invented, so there is no genuine explanation for it. The curious thing about this story, though, is that if it were told and retold enough times by the readers of this book it might itself turn into an Urban Legend.

CAN YOU TELL ANYTHING ABOUT THIS PERSON BY HIS APPEARANCE?

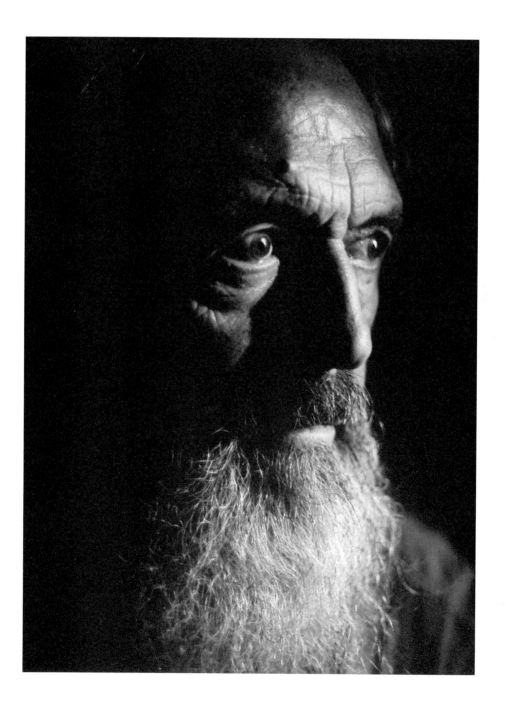

CAN YOU TELL ANYTHING ABOUT THIS PERSON BY HIS APPEARANCE?

At one time there was thought to be an art of reading character from faces. This art was called physiognomy. You can judge whether there is such an art by asking yourself whether you can say anything about the character or persona of the man on the previous page just by looking at him?

Maybe you think you can say something vague about the character of this man by studying his face. Perhaps his appearance makes you want to say that he is serious and intelligent. Perhaps the fact that he is staring so intensely makes you want to say that he is highly analytical. Now consider whether your initial judgement is challenged when I tell you that this is a photograph of the artist Ken Woodward. On reading this information do you start to see more artistic features in his character?

Clearly there is something of an art to reading faces, but equally there is also something of an art to reading objects. The Volkswagen Beetle is a classic example of how character and persona might be read into an object. The designers of the VW Beetle ensured that it had a character and personality by using what has been called 'cute' styling. When designers use 'cute' styling they draw on the characteristics of human, and sometimes non-human, babies for inspiration. Human babies have rounded features, prominent foreheads, tiny noses, large eyes and short chins, all of which gives them a character and personality that appears to be honest, pure, vulnerable and naive. These features were mimicked in the VW Beetle, with the curves of its body, the large round lights and the smoothness of its detailing. And it is this form of styling that helps to explain the feelings of affection we have for it. (This explanation also helps to account for the popularity of the *Herbie* movies of the 1960s and 1970s – movies that imbued a particular VW Beetle with a personality and life that was independent of the wills of its owners.)

WHAT IS CURIOUS ABOUT THIS PHOTOGRAPH?

WHAT IS CURIOUS ABOUT THIS PHOTOGRAPH?

The stories that we tell about the world can always be presented from different viewpoints. And the viewpoint from which we choose to present a story will always influence how we read it.

News stories are often presented from a viewpoint that is apt to seem impartial. They are usually filmed in such a way that the viewer is able to feel that the events that are being portrayed are simply being documented rather than framed with a certain agenda in mind. However, we know that each shot has been chosen, each angle has been arranged and each image has been composed. This, along with editing, voice-overs and other forms of post-production, aids and abets the outcome. And this should make us realize that most news stories merely present things from one carefully chosen viewpoint. In short, they are not as objective as they might at first seem.

The photograph overleaf is of a group of people standing in front of the *Mona Lisa*. The viewpoint from which it has been taken is unusual because most visitors to the Louvre in Paris take a photograph of the *Mona Lisa* itself rather than of the people who are standing in front of it. There are various reasons why people might want to photograph the painting rather than its audience. One is that they may wish to record the experience they have had. (This may be so that they can prove to their friends that they have actually seen the painting.) I chose to take this picture from a different viewpoint in order to demonstrate that even though the visitors to the gallery feel pleased to be in the presence of this picture they do not always feel obliged to look at it. In short, the picture has an 'aura' that appears to transcend how it looks.

WHAT HAPPENED TO THESE PEOPLE?

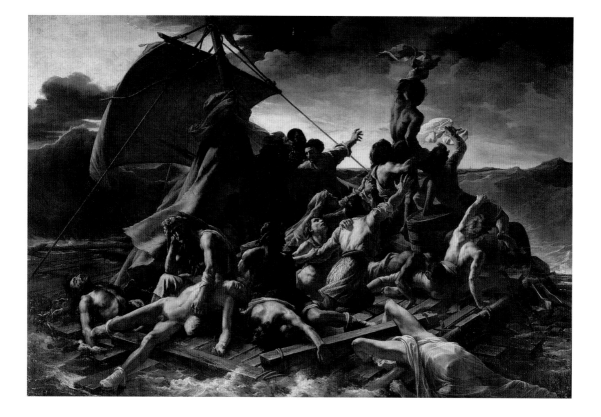

WHAT HAPPENED TO THESE PEOPLE?

Part of any good story is mystery. Mystery gives us a place for speculation. In his *The Raft of the Medusa* (1819) in the Louvre, Théodore Géricault chooses a narrative moment about which we can only wonder. Some things we know already. The picture represents a shipwreck. The *Medusa* hit a reef on the afternoon of July 2nd, 1816. It seems that there was insufficient food on the raft and that the wounded became the victims of cannibalism. We also know that some 15 days later those that had survived were rescued.

It is the job of a news reporter to be true to life, though that may not be the job of the painter. His job is to make art. And if truth gets in the way of making good art, then some artists think that truth may have to be sacrificed. One mystery is the extent to which Géricault was willing to sacrifice the truth in order to keep a sense of wonder

in his picture. Géricault, it appears, went to some lengths to ensure that his picture was accurate. He read the reports of two survivors of the wreck, Henri Savigny and Alexander Corréard. He also interviewed them. But were they telling the truth, and did Géricault represent the truth as they told it? Why did he not depict the cannibalism that was alleged to have taken place? And why did he depict so many people on the raft when Savigny and Corréard had told him there were only 15 survivors? It is something of a mystery.

Stories always change in the telling. The facts may be altered, the characters improved, the details enhanced and the chronology of the events changed. So when we are told a story – any story – do we really want to know what really happened, or do we care more about the mysteries that make the story interesting?

WHICH IS THE BEST STORY?

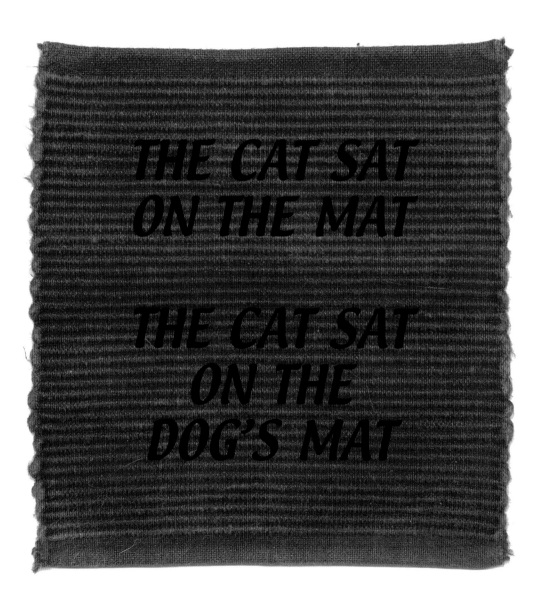

WHICH IS THE BEST STORY?

The cat sat on the mat. If this is a story, then there is not much to it. The cat sat on the dog's mat. This is a better story because some form of tension has been created and, as a result, we can imagine something dramatic happening. (Stories take place when something happens. If nothing happens then there is no story.) When we know that the cat has sat on the dog's mat we want to ask: 'Why did the cat sit on the dog's mat? What happened when the dog found out? Was he angry about it? Was he nonchalant? Did the cat get away with it in the end?' Of course, we can ask why the cat sat on the mat, but the reply we receive may be found wanting.

We tend to think of narrative tensions as existing mainly in texts. However, there are also narrative tensions in objects. For example, the objects of Postmodern design are given such a tension by the way in which they meld styles (old and new), materials (valuable and cheap, brand-new and second-hand) and processes of manufacture (industrial and hand-made). These objects create a challenge for the standard linear narratives of design history. This is because by melding such different styles, materials and processes of manufacture from different epochs, the meanings of these objects, in terms of their place in history, starts to fracture. For although they can be accurately dated they still seem to belong to different parts of the past all at once.

Narrative tensions can arise in images, too. This often happens in documentary photography. In order to create a sense of narrative a photographer will often freeze an action shot at the moment that is most dramatic (e.g., when someone is hitting a ball in a sports match). By capturing the moment in this way the photographer suggests what might have come before the moment and what might occur after it. The stillness of the action, then, creates both narrative tension and expectation.

WHAT HAPPENED NEXT?

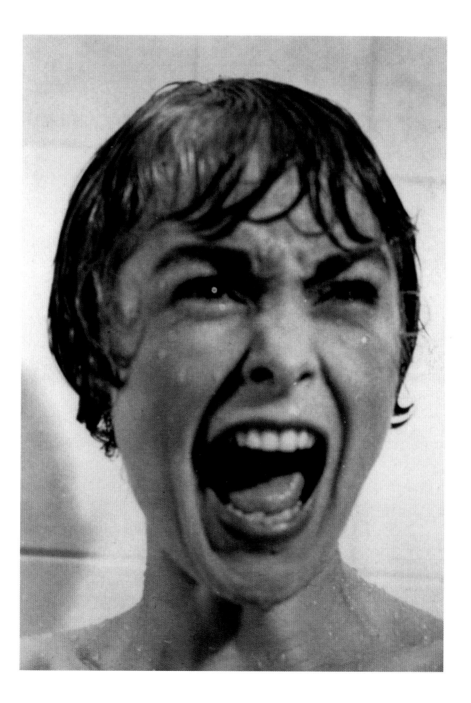

WHAT HAPPENED NEXT?

Turning-points are often at their most obvious in the cinema. What happens in Hitchcock's famous film *Psycho* (see the still from the film on the previous page) – but skip this paragraph if you have not yet seen the film – is that a turning-point occurs when the protagonist played by Janet Leigh is suddenly murdered. This event provides the turning-point in the film because up until then the story appeared to be about the theft of some money. Following this event, the story becomes about whether, among other things, the police will discover, first, that this woman has been murdered, and second who the perpetrator is.

Turning-points consist in key moments when something occurs that brings about a change. In narratives this usually requires there to be a significant contrast between that which happened before a set of events and that which will happen after them. Often the turning-point is spectacular, exciting or extraordinary. History is said to have its turning-points when an important and sudden event leads to a big change (e.g., the murder of Archduke Franz Ferdinand that led to World War I). Music is said to have its turning-points when there is an abrupt change in rhythm, harmony or melody (e.g., the first movement of Beethoven's Fifth Symphony). Speech is said to have its turning-points where there is an unexpected change in tone or emphasis in terms of sound (e.g., the famous speech that includes the phrase 'I have a dream…' made by the civil rights protester Dr. Martin Luther King). Strangely, we tend not to think of objects as having turning-points, even though they can have them. The turning-point in the life of an object might be the moment when it is first used, when it is broken, when it is sold, when it is lost or when it is given as a gift.

THERE IS A ZEN BUDDHIST STORY THAT BEGINS WITH A QUESTION:

'WHAT SHOULD YOU DO IF YOU SEE BUDDHA ON THE ROAD?'

'WHAT SHOULD YOU DO IF YOU SEE BUDDHA ON THE ROAD?'

The answer is that you should kill him, because Zen Buddhism is about the inner life. This response is shocking and surprising. It is memorable. But it is also puzzling, and so requires an explanation.

Zen is a form of religious teaching through stories, which are supposed to give insight into the human condition and what makes it valuable. Often the stories have unexpected conclusions, like this one. This is because Zen masters – those who were well-practised in the art of Zen – want to change our perceptions by making us dwell on what we think we know about life. In many Zen stories the focus is on the inner world of human beings rather than on their physical side. So the story about killing Buddha on the road need not be taken literally. Instead, it may only be there to remind us, albeit in a dramatic fashion, of what it is to be an enlightened human being, which is to say a being who dwells on the inner life of the mind rather than on the outward expressions of the body.

In stories, as in life, we want things to be resolved. In wanting resolution we might say that we fetishize the idea of things having endings. That is why we look for medical cures to be discovered, for legal pronouncements to be decided, for educational programmes to be completed, for jobs to be finished and for stories to reach an end. And it is surely no accident that life itself is often seen in terms of a journey and its final resolution. In wishing for these things to be resolved, though, we should not forget the value of the journey that takes us to the resolution itself. It is this journey, as philosophy itself has shown, that can often be as valuable as the destination. In fact, even when we reach the destination we may sometimes find ourselves miraculously back at the beginning.

Once upon a time, there was a book on semiotics called *This Means This, This Means That....*

CONCLUSION

Even though semiotics has seminal texts, established procedures, scholarly debate, publications and an academic history, it is, as we have seen, still a rather diverse and eclectic subject. This diversity and eclecticism, particularly in terms of its methods, stems from the many different disciplines that it uses for inspiration, including: linguistics, anthropology, psychology, philosophy, sociology, art history, communication studies, media studies and material culture. The result of this is that the subject has both a weakness and a strength. Its weakness is that there is no body of knowledge of which semiotics can be certain. Its strength is that the absence of such a body of knowledge gives it the freedom to explore new ways of thinking, avenues of interest and novel ways of exploring meaning. In other words, because it does not have the doctrinal quality of other intellectual disciplines, semiotics can be actively done rather than just passively learnt and digested. For in semiotics we don't simply decipher a coded meaning and leave it at that. Instead, we are asked continually to reinterpret, reformat, rework, rethink and reinvigorate the meanings that we find around us. And this is what makes it such a rewarding subject to investigate.

BIBLIOGRAPHY

Adair (1992) *The Postmodernist Always Rings Twice*, London: Fourth Estate.

Adams, James L. (2001) *Conceptual Blockbusting: A Guide to Better Ideas* (4th edition), Cambridge, MA: Perseus Books.

Aitchison, Jean (2002) *Words in the Mind* (3rd edition), Oxford: Blackwell.

Arnheim, Rudolf (1974) *Art and Visual Perception: A Psychology of the Creative Eye* (revised edition), Berkeley: University of California Press.

Arnheim, Rudolf (1988) *The Power of the Center: A Study of Composition in the Visual Arts*, Berkeley: University of California Press.

Augard, Tony (2003) *The Oxford Guide to Word Games* (2nd edition), Oxford: Oxford University Press.

Barnes, Julian (1995) *A History of the World in 10½ Chapters*, Cambridge: Cambridge University Press.

Barry, Peter (2002) *Beginning Theory: An Introduction to Literary and Cultural Theory* (2nd edition), Manchester: Manchester University Press.

Barthes, Roland (1977) *The Elements of Semiology*, New York: Hill and Wang.

Barthes, Roland (1984) *Image, Music, Text*, London: Flamingo.

Barthes, Roland (1993) *Mythologies*, London: Vintage.

Barthes, Roland (1990) *The Pleasure of the Text*, Oxford: Blackwell.

Beaney, Michael (ed.) (1997) *The Frege Reader*, Oxford: Blackwell.

Berger, John (1972) *Ways of Seeing*, Harmondsworth: Penguin.

Blonsky, Marshall (ed.) (1985) *On Signs*, Oxford: Blackwell.

Bowker, Geoffrey C. and Star, Susan L. (1999) *Sorting Things Out: Classification and its Consequences*, Cambridge, MA: MIT Press.

Butler, S. William and Keeney, L. Douglas (2001) *Secret Messages: Concealment, Codes, and Other Types of Ingenious Communication,* New York: Simon and Schuster.

Chandler, Daniel (2002) *Semiotics: The Basics*. London: Routledge.

Cobley, P. (ed.) (1996) *The Communication Theory Reader*, London: Routledge.

Cobley, P. and Jansz, L. (1997) *Semiotics for Beginners*, Cambridge: Icon.

Culler, Jonathan (1976), *Saussure*, London: Fontana.

Dale, Rodney (2005) *Book of Urban Legend*, Ware: Wordsworth Editions.

Danesi, M. (1999) *Of Cigarettes, High Heels, and Other Interesting Things*, Basingstoke: Macmillan.

Donnellan, K. (1966) 'Reference and Definite Descriptions', *Philosophical Review*, LXXV.

de Duve, Thierry (1996) *Kant after Duchamp*, Cambridge, MA: MIT Press.

Fiske, John (1990) *An Introduction to Communication Studies* (2nd edition), London: Routledge.

Gerbner, G. (1956) 'Towards a general model of communication', *Audio Visual Communication Review*, IV:3, pp. 171–99.

Goddard, Angela (2002) *The Language of Advertising* (2nd edition), London: Routledge.

Gombrich, E. H. (1977) *Art and Illusion* (5th edition), London: Phaidon.

Gombrich, E. H. (1979) *Ideals and Idols: Essays on Values in History and in Art*, Oxford: Phaidon.

Gombrich, E. H. (1986) *The Image and the Eye: Further Studies in the Psychology of Pictorial Representation*, Oxford: Phaidon.

Gordon, W. Terrence (1996) *Saussure for Beginners*, New York: Writers and Readers.

Harding, Nick (2005) *Urban Legends*, Harpenden: Pocket Essentials.

Hawkes, Terence (2003) *Structuralism and Semiotics* (2nd edition), London: Routledge.

Jackson, Kevin (1999) *Invisible Forms: A guide to Literary Curiosities*, London: Picador.

Jakobson, Roman 'Closing statement: linguistics and poetics' in Sebok, T. (ed.) (1969) *Style and Language*, Cambridge, MA: MIT Press.

Jakobson, Roman and Halle, Morris (2002) *The Fundamentals of Language*, Herndon: Walter de Gruyter.

Jaworski, Adam and Coupland, Nikolas (ed.) (1999) *The Discourse Reader*, London: Routledge.

Jean, Georges (1998) *Signs, Symbols and Ciphers: Decoding the Message*, London: Thames and Hudson.

Kress, Gunter and Van Leeuwen, Theo (2006) *Reading Images: The Grammar of Visual Design* (2nd edition), London: Routledge.

Lakoff, George and Johnson, Mark (2003) *Metaphors We Live By* (reprint), Chicago: University of Chicago Press.

Lasswell, H. 'The structure and function of communication in society' in Bryson, L. (1948) *The Communication of Ideas*, New York: Institute for Religious and Social Studies.

Leach, Edmund (1970) *Claude Levi-Strauss*, Chicago: Chicago University Press.

Levi-Strauss, Claude (1969) *The Raw and the Cooked: Introduction to a Science of Mythology*, London: Pimlico.

Lidwell, William, Holden, Kritina and Butler, Jill (2003) *Universal Principles of Design*, Gloucester, MA: Rockport.

McLuhan, Marshall (2001) *Understanding Media: The Extensions of Man* (reprint), London: Routledge.

Marquart, Christian (1998) *Beetlemania: Return of the Bug*, Frankfurt: Verlag Form.

Moore, A. W. (ed.) (1993) *Reference and Meaning*, Oxford: Oxford University Press.

Morris, Desmond (1962) *The Biology of Art: A Study of the Picture-making Behaviour of the Great Apes and Its Relationship to Human Art*, London: Methuen.

Nagel, T. (October, 1974) 'What is it like to be a bat?', *Philosophical Review*, LXXXIII.

Ogden, Charles Kay and Richards, Ivor Armstrong (1989) *The Meaning of Meaning: A Study of the Influence of Language upon Thought and of the Science of Symbolism* (reprint), San Diego: Harcourt Brace Jovanovich.

Papanek, Victor (1995) *The Green Imperative: Ecology and Ethics in Design and Architecture*, London: Thames and Hudson.

Pierce, Charles Sanders (1958) *Collected Papers*, Cambridge, MA: Harvard University Press.

Pierce, Charles Sanders (1998) *The Essential Pierce: Selected Philosophical Writings* (2 vols). Bloomington: Indiana University Press

Perec, Georges (1997) *Species of Spaces and Other Pieces*, London: Penguin.

Putnam, H. 'Meaning and reference' in Moore, A. W. (ed.) (1993).

Reps, Paul (compiler) (1994) *Zen Flesh, Zen Bones: A Collection of Zen and Pre-Zen Writings*, London: Shambhala.

de Saussure, Ferdinand (1983) *Course in General Linguistics*, London: Duckworth, trans. Harris, Roy

de Saint-Exupéry, Antoine (2005) *The Little Prince*, London: Egmont and Harcourt.

Sebok, Thomas, S. 'Pandora's Box: how and why to communicate 10,000 years into the future' in Blonsky, Marshall (ed.) (1985).

Shannon, Claude. and Weaver, Warren (1998) *The Mathematical Theory of Communication* (reprint), Urbana: University of Illinois Press.

Thwaites, Tony, Davies, Lloyd, and Mules, Warwick (1996) *Tools For Cultural Studies: An Introduction*, South Melbourne: Macmillan Education Australia.

Van Leeuwen, Theo (2005) *Introducing Social Semiotics*, London: Routledge.

Varasdi, J. Allen (1996) *Myth Information*, New York: Ballantine Books.

Weaver, Warren 'Recent contributions to the mathematical theory of communication', Appendix to Shannon and Weaver (1949).

Williamson, Judith (1983) *Decoding Advertisements: Ideology and Meaning in Advertising*, London: Boyars.

Wittgenstein, Ludwig trans. G. E. M. Anscombe (1953) *Philosophical Investigations* (3rd. edition), Oxford: Blackwell.

PICTURE CREDITS

Figures in bold refer to page numbers

9–10 Lucas Cranach, *Adam and Eve*, 1526. Oil on panel, 117 x 80 cm (46 x 31½ in). Courtauld Institute, London. Acquisition Lee of Fareham, Arthur Hamilton (1st Viscount); bequest; 1947. P.1947.LF.77. Bridgeman Art Library.

13–14 *Inuit Wooden Map*. The Greenland National Museum & Archives. © The Greenland National Museum and Archives.

15–16 Cindy Sherman, *Untitled Film Still 153*. Courtesy of the artist and Metro Pictures.

21–22 Congo, *Composition on Black Paper*, 13 March 1958. © Desmond Morris, courtesy of the Mayor Gallery.

23–24 Barbara Kruger, *I shop therefore I am*, photographic silkscreen on vinyl, 284.5 x 287.5 cm (112 x 113 in). Private Collection. Courtesy Thomas Ammann Fine Art Zürich.

25–26 Leonardo da Vinci, *Mona Lisa*, c. 1503. Oil on panel, 97.8 x 53.3 cm (38½ x 21 in). Musée du Louvre, Paris. © Studio Fotografico Quattrone, Florence.

31–32 Robert Jackson, *Jack Ruby Shoots Lee Harvey Oswald at Dallas Police Station* (detail), 24 November 1963. Everett Collection/Rex Features.

37–38 Johannes Eisele/AFP/Getty Images (37 left and 38 top left). Nina Dodd/Rex Features (37 right and 38 top right). Marianne Rosenstiehl/Sygma/Corbis (38 bottom).

49–50 Piero della Francesca, *Baptism of Christ*, c. 1445. Egg tempera on wood panel, 167 x 121.2 cm (5 ft 5¾ in x 3 ft 11¾ in). National Gallery, London.

51–52 After de Saint-Exupéry, Antoine (2005) *The Little Prince*, London: Egmont and Harcourt, p. 1.

55–56 René Magritte, *The Betrayal of Images ("This is not a pipe")*, c. 1928–29. Oil on canvas, 60 x 94 cm (23⅜ x 37 in). Los Angeles County Museum of Art, California. Purchased with funds provided by the Mr. and Mrs. W.P. Harrison Collection. 1996. 78.7. © [René Magritte/Los Angeles County Court Museum of Art, California]. Licensed by ADAGP, Paris and DACS, London 2007.

63–64 Paolo Uccello, *Battle of San Romano*, c. 1435–60. Panel, 1.86 x 3.23 m (6 ft x 10 ft 5 in). National Gallery, London.

77–78 Eugène Delacroix, *The 28th July: Liberty Leading the People*, 1830 (Salon of 1831). Oil on canvas, 2.6 x 3.25 m (8 ft 6 in x 10 ft 8 in). Musée du Louvre, Paris. © Photo Josse, Paris.

79–80 Bayeux Tapestry (detail), late 11th century. Wool embroidery on linen, depth approx. 50.8 cm (20 in), entire length 70.4 m (231 ft). Town of Bayeux, France. Photo: By special permission of the City of Bayeux.

81–82 Michelangelo Buonarroti, c. 1550–53. Marble, height 2.26 m (7 ft 5 in), Museo dell'Opera del Duomo, Florence. Photo: Scala, Florence.

83–84 M.C. Escher, *Mosaic II*, 1957. © 2007 the M.C. Escher Company – the Netherlands. All rights reserved. www.mcescher.com.

87–88 Masaccio, *Tribute Money*, 1426–28. Fresco, Cappella Brancaci, Santa Maria del Carmine, Florence. © Studio Fotografico Quattrone, Florence.

89–90 Still from Fritz Lang, *Metropolis*, 1926. UFA/The Kobal Collection.

91–92 Colin O'Brien, *Lightning Over London*, photograph. Courtesy of Colin O'Brien.

115–16 After Stokoe, W.J. (ed.) *The Observer Book of Trees* (1970), London: Frederick Warne & Co. Ltd, pp. 105 and 139.

125–26 By courtesy of Anything Left-Handed Ltd, anythingleft-handed.co.uk.

127–28 Sandro Botticelli, *Birth of Venus*, c.1485–86. Tempera on canvas, 1.73 x 2.77 m (5 ft 9 in x 9 ft 2 in). Galleria degli Uffizi, Florence. © Quattrone, Florence.

129–30 Marcel Duchamp, *Fountain*, 1917. Ready-made, height 62.5 cm (24⅜ in). Courtesy Sidney Janis Gallery.

137–38 Thomas Gainsborough, *Mr and Mrs Andrews*, c. 1750. Oil on canvas, 69.8 x 119.4 cm (27½ x 47 in). National Gallery, London.

141–42 Carl André, *Equivalent VIII*, 1966. 120 firebricks (12.5 x 274 x 57 cm (95 x 106½ x 22½ in). © [Carl André/The Tate, London]. Licensed by DACS, London 2007 and VAGA, New York.

143–44 Historical Instruments and Manuscripts Collection, Royal College of Music. Photo: Andreas Schmidt.

145–46 *What's Up South* map. © 2007, odtmaps.com. For maps and other related teaching materials contact: ODT, Inc., PO Box 134, Amherst MA 01004 USA; Tel: 413-549-1293; Fax: 413-549-3503; E-mail: odtstore@odt.org. Web: odtmaps.com.

147–48 Pat Behnke/Alamy

149–50 Van Gogh, *Portrait with Bandaged Ear*, 1889. Oil on canvas, 60 x 49 cm (23⅜ x 19⅓ in). Samuel Courtauld Trust, Courtauld Institute of Art Gallery, London/The Bridgeman Art Library.

151–52 Sigmund Freud, *Doodle*. Library of Congress, Washington, DC.

155–56 Masalino, *Crucifixion*, fresco, left (south wall), lower band, Chapel of the Sacrament, S. Clemente, Rome, 1428–32. © Vincenzo Pirozzi, Rome fotopirozzi@inwind.it

165–66 Théodore Géricault, *The Raft of the Medusa*, 1819. Oil on canvas, 4.9 x 7.16 m (16 ft x 23 ft 6 in). Musée du Louvre, Paris. © Photo Josse, Paris.

169–70 Still from Alfred Hitchcock, *Psycho*, with Janet Leigh, 1960. SNAP/Rex Features.

 Laurence King Publishing has paid DACS' visual creators for the use of their artistic works